Party
Animals™
Washington, DC

GOVERNMENT OF THE DISTRICT OF COLUMBIA
D.C. COMMISSION ON THE ARTS AND HUMANITIES

Mayor Anthony A. Williams

DC Commission on the Arts and Humanities
Dorothy Pierce McSweeny, *Chair*
Lou Stovall, *Vice Chair*

Anthony Gittens, *Executive Director*
Alexandra MacMaster, *"Party Animals" Project Manager*
Samantha Lane, *"Party Animals" Project Assistant*

Commissioners:

Felix Angel
Max. N. Berry
Kathleen Donner
Lucius Durden
Cathy James Ehrman
Isabella Gelletich
Derek Gordon
George Koch

B. Warren Lane
David Levy
Lee Kimche McGrath
E. Ethelbert Miller
Franklin S. Odo
Maurice Shorter
Marilyn Weiner

410 Eighth Street, N.W., Fifth Floor, Washington, D.C. 20004 (202) 724-5613 TDD: (202) 727-3148 Fax: (202) 727-4135
http://www.capaccess.org/dccah

Party Animals™
Washington, DC

DC Commission on the Arts and Humanities

ORANGE FRAZER PRESS
Wilmington, Ohio

ISBN 1-882203-87-9
Copyright 2002 by DC Commission on the Arts and Humanities

Additional copies of Party Animals: Washington, DC may be ordered directly from:
Orange Frazer Press
P.O. Box 214
Wilmington, OH 45177

Telephone 1.800.852.9332 for price and shipping information
Website: www.orangefrazer.com

Text: Tony Gittens, Dorothy McSweeny, Lou Stovall.
Photography: John Woo, COPY PHOTOGRAPHY OF YOUR ARTWORK, Judy Licht, Writer/Photographer.
Editors: Lou Stovall, Tony Gittens, Julia Holmes.
Design: Lou Stovall, Orange Frazer Press, Tim Fauley, Marcy Hawley, Tony Gittens.
Cover design by Orange Frazer Press: Marcy Hawley, Art Direction; Tim Fauley, Design

Library of Congress Cataloging-in-Publication Data

Party animals, Washington, DC : April-September 2002 / DC Commission
on the Arts and Humanities ; photography by John Woo.
 p. cm.
 Includes index.
ISBN 1-882203-87-9 (alk. paper)
1. Art, American—Washington (DC)—21st century—Exhibitions. 2. Public art—Washington (DC)—Exhibitions. 3. Art—Political aspects—Washington (DC)—Exhibitions. 4. Donkeys in art—Exhibitions. 5. Elephants in art—Exhibitions. I. Woo, John, 1962- II. DC Commission on the Arts and Humanities.
N6535.W3 P37 2002
730'.9753—dc21
 2002031273

Printed in Canada

Text:
Tony Gittens
Dorothy McSweeny
Lou Stovall

Photography:
John Woo (principal)
Judy Licht (supplemental)

Editors:
Lou Stovall
Tony Gittens
Julia Holmes

Project Chairman:
Dorothy McSweeny

Project Managers:
Alexandra MacMaster
Samantha Lane

Public Relations:
Crabtree & Company
Fleishman Hillard
Greenfield/Belser
WMATA

Design:
Lou Stovall &
Orange Frazer Press

Party Animals, Washington, DC exhibition and book is dedicated to all of the artists who have brought so much to the cultural life of our city.
We remember Lee Kimche McGrath and Larry Rivers.

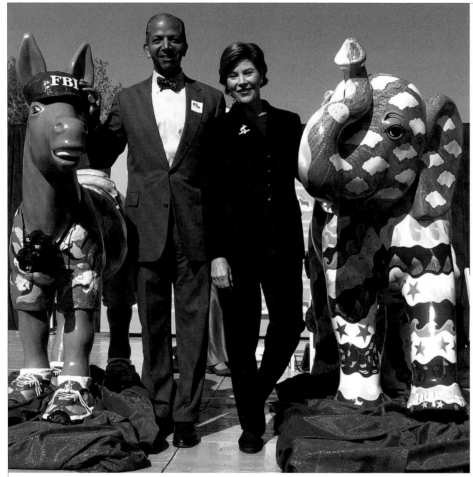

Photo by: Lateef Mangum

DC Party Animals Unveiled

Remarks by Laura Bush
April 23, 2002

THANK YOU, MAYOR WILLIAMS. Thanks also to the DC Council; the DC Commission on the Arts and Humanities and the sponsors and artists for giving Americans one more reason—or should I say 200 more reasons!—to visit our Nation's Capital this spring and summer. "Party Animals" is a terrific arts project that celebrates the talent and creativity of Washington-area artists and two symbols of our nation's democracy.

The donkey and the elephant first appeared in public in the 1870s—in Harper's Weekly magazine. That's when political cartoonist Thomas Nast used them to make satirical jabs at the politicians of the day.

You might say that his efforts backfired: the animals have instead become much-loved symbols of American politics. Today we present two of the symbols in a new and rare form...and you'll find even more of them around town.

President Bush and I invite Americans to visit Washington, DC this summer and take a Party-Animal safari...You'll find 200 creatively designed creatures throughout the District with the help of a Party Animals Tour Guide Map...and a little imagination.

[1] The donkey first appeared in a cartoon in *Harper's Weekly* in 1870, and was supposed to represent an anti-Civil War faction. But the public was immediately taken by it and by 1880 it had already become the unofficial symbol of the party. In 1874, Nast drew a donkey clothed in lion's skin, scaring away all the animals at the zoo. One of those animals, the elephant, was labeled "The Republican Vote." That's all it took for the elephant to become associated with the Republican Party.

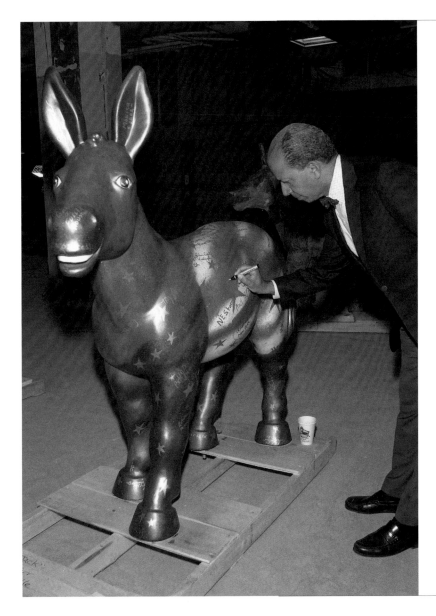

ANTHONY A. WILLIAMS
MAYOR

AS MAYOR OF THE DISTRICT OF COLUMBIA, I want to thank you for your support of Party Animals, our city's public art project expressing the more whimsical side of the Nation's Capital.

Party Animals is not only a cultural project, it is also an investment in the economic development of our city. We thank the scores of sponsors from the business and international communities who have contributed their time and resources to this effort. As you know, artists and arts educators are key to insuring a balanced experience for our young people. I am very pleased to say that proceeds from the Party Animals Auction will benefit the grant and arts education programs of the DC Commission on the Arts & Humanities.

During your Party Animals tour, many of you took time to visit the galleries, museums, theaters, restaurants, educational institutions and many other distinctive destinations to be found in our vital neighborhoods. They all make this city unique.

I would like to especially thank the DC Commission on the Arts & Humanities and all of the artists involved for their extraordinary work on Party Animals. This is a world-class art showcase. I believe that the 21st century is the century of cities. Party Animals illustrates that municipalities continue to be cultural hubs, where modern living can be coupled with creativity and imagination.

On behalf of the residents of the District of Columbia, you have my deepest appreciation for making Party Animals the most successful public art project in the history of our city.

Sincerely,

Anthony A. Williams
Mayor, District of Columbia

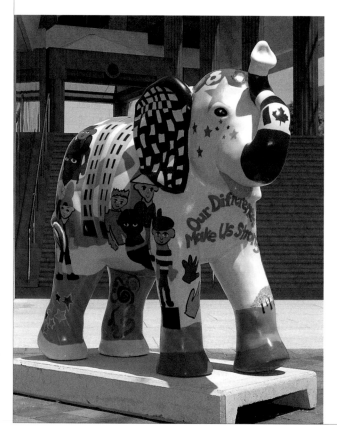

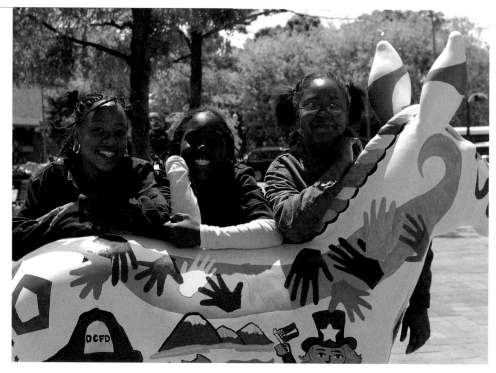

Left to right:

CHILDREN UNITED IN PEACE
Henry Smothers Elementary School
The Canadian Embassy

CHILDREN UNITED IN PEACE
Henry Smothers Elementary School
The Canadian Embassy

The Unexpected and the Beautiful

PARTY ANIMALS IS THE LARGEST public art project in the history of Washington, DC. Inspired by the successes of Chicago's Cows on Parade and similar public arts projects in other cities, we at the DC Commission on the Arts and Humanities knew Washington and its artists could only benefit from a chance to display their creativity, generosity, and profound sense of community to the rest of the world. Over a period of nine months, the DC Arts Commission worked diligently to turn over hundreds of well-formed, near life-sized creatures—one hundred elephants and one hundred donkeys—to artists. Party Animals was an opportunity to exhibit Washington's abundant creative talent and energy. In a city notorious for taking itself a bit too seriously, it was an opportunity to have some fun.

The Party Animals public art project was launched by Mrs. Laura Bush, First Lady of the United States, and Anthony Williams, Mayor of the District of Columbia on April 23rd, 2002. The event received over 200 national media mentions that day alone from major media such as The Washington Post, CNN and NBC-TV's Today Show. But most importantly, Washingtonians began rounding the corners of downtown streets, emerging from Metro entrances and stepping out of their homes and offices to unexpectedly discover a herd of striking and strangely endearing animal sculptures.

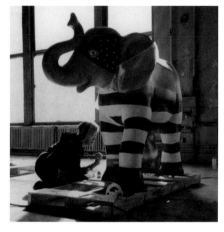

Evolution of Party Animals

TONY GITTENS, EXECUTIVE DIRECTOR, DC Commission on the Arts and Humanities, identified the funding and secured the approval of the Arts Commission Board to move forward with the challenging public art project. We needed to identify the icon true to Washington's character and essence. The Commission considered pandas, eagles, and even squirrels. Once we arrived at donkeys and elephants, there was immediate consensus: that's Washington, DC! DC Arts Commission Chair, Dorothy McSweeny,

suggested the title Party Animals, and began raising scores of Party Animal sponsorships to engage the support and partnership of businesses, foundations and city and federal governments. We first planned to present a donkey and an elephant together as a single sculpture, their arms around each other in a lighthearted gesture of political cooperation. But Lou Stovall, artist and Vice Chairman of the DC Arts Commission, pushed to focus on molding the four-legged creatures apart and in a more generic form. Stovall passionately explained that the artists would require a smooth, broad canvas on which to do their best work.

In our role as the nation's capital and as a world leader, we invited artists from national and international communities to participate. We sent 10,000 invitations and received over twelve hundred submissions. We were not looking for political statements; we were looking for fine public art. Artists were drawn to the challenge and fun of the project, and we received many beautiful, clever, and imaginative designs. We were astounded by the diversity of visions that the contest inspired.

From the moment the animals arrived by truck in February, everyone pitched in with donations of equipment, assistance, and support. Alexandra McMaster, assisted by Samantha Lane, managed project logistics. Greenfield-Belser designed the perfect logo, an elephant and donkey dancing in the spotlight. Fleishman Hillard became our public relations firm and media coach. And the artists went to work...

Community As Usual

WE WERE ALL ENTHUSIASTIC about the importance of Party Animals being a community project. But where would we stable 100 donkey and 100 elephant sculptures while the artists worked? Douglas Jemal, of Douglas Development Corporation and lover of art and history, stepped forward to offer the Woodward and Lothrop Department Store Building ("Woodies"), which is awaiting its turn to be refurbished, rehabilitated, and returned as the flagship of downtown Washington. Woodies became the perfect studio space for nearly two hundred artists. Because Woodies is a converted department store, not an engineered "studio space," we had some basic challenges like heat, lighting,

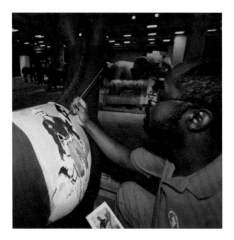

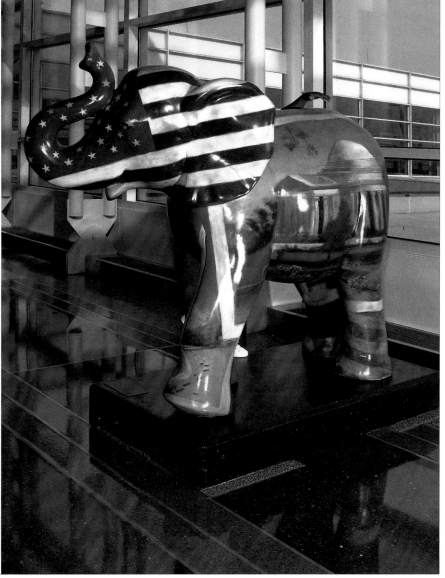

MONUMENTAL WASHINGTON
Sharon Roy Finch
Washington Convention
& Tourism Corporation

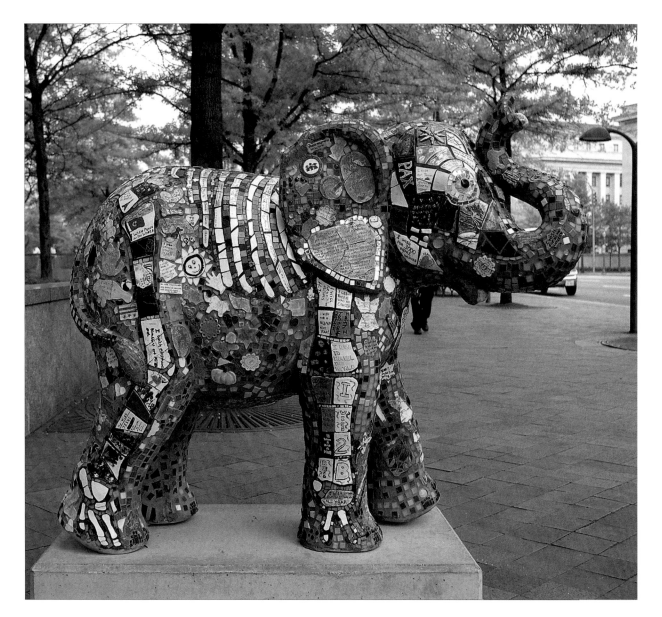

ELEPHANT WISDOM
Lombardi Cancer Center
Tracy Dee Councill
Dorn & Lee Kimche McGrath

water and weak elevators. Everyone had to help out in order for it to work, and it did work. The level of enthusiasm was incredible. Artists were excited about getting to work and working together.

Over the course of the Party Animals project, artists at Woodies lived the entire arc of an artist's life in just a few weeks—they went from the cold of winter to the heat of summer, from low light to intense, direct sunlight. Visual artists tend to work apart from each other, but a project like Party Animals allows them to share ideas, techniques, and friendships. Many area artists met for the first time, and they met artists from around the country and abroad. Even those artists who worked at home in their own studios came to Woodies often so they could participate with the community. For the artists, this was "better than art school"—a room full of other artists from whom they could borrow paint, supplies, get support, exchange ideas and technical assistance.

In addition to local, national and international artists, children in the Washington, DC area contributed to the project. Sponsored by the Canadian Embassy, students at the Smothers School, a public school in Northeast Washington, designed and painted a donkey and an elephant. Everyone at the school—the principal, custodial staff, teachers, and students, all helped to bring the animals into the school. Their animals were painted in the Auditorium/Dining Hall. Children at the Lombardi Cancer Center, who are in treatment at the pediatric cancer facility, created a "Wish Elephant"—children drew and wrote wishes on tiles, which were then arranged in a mosaic on the elephant.

The Pataspco School in Baltimore designed the "Periodic Table of Elephants," which the students painted with inventive puns and images for the real elements on the Periodic Table. Crabtree + Company sponsored the elephant and the American Chemical Society plans to buy it at auction to develop as an educational tool. Other schools which participated and played an important role for their communities were Lake Anne Elementary, Community of Hope, Banneker High School, P.G. Home Learning Network and Friends, and Rutledge Home School.

We made many discoveries, connections, and friends throughout this process. Washington, DC is a uniquely complicated intersection of federal, municipal and international governments; businesses and cultural organizations; universities and labor associations; residents and visiting tourists. As we launched Party Animals, we discovered, or rediscovered, the desire among people in this city to contribute and participate in a project that was about fun, creativity, and goodwill. Party Animals built bridges. Diverse groups such as, The Metropolitan Transit Authority, The Department of Public Works, The Department of Transportation, Clark Construction Company, Douglas Development Corporation, international embassies, The National Park Service, Hecht's, The Washington Post, The Washington Times, Fannie Mae, McCormick and Schmick restaurants, hotels, caterers, law firms, businesses and many other organizations concurrently contributed their time, services, and energy. The DC Arts Commission board and staff provided endless hours of hard work and good cheer. Many people

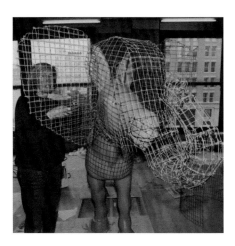

expressed their love and devotion to this city through their commitment to this project. Artists—and others in Washington—love this city and take advantage of any opportunity to make a contribution to the community.

We wanted to place the sculptures in every part of the city, not just in the tourist or commercial districts. Michael McBride of the Metropolitan Transit Authority led the Party Animals staff in studying maps and determining the most appropriate sites. Sculptures were placed in every sector of Washington. Because thousands of people pass by Metro entrances every day, Metro stations became prime locations. In addition to working with Metro, we worked closely with businesses, and institutions of all kinds. The diplomatic community also asked to be involved, and elephants and donkeys were sighted in front of the British, Turkish, Canadian, and Swiss Embassies.

Politics As Usual
JUST AS THE DONKEYS and elephants may be considered true reflections of Washington's

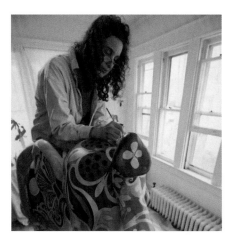

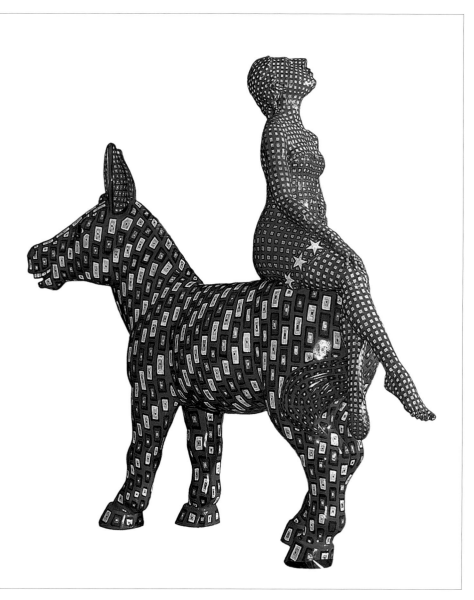

CATCH A RIDE TO THE PARTY
Herb Witenstein
Embassy Suites at ChevyChase Pavilion-Lowe
Enterprises-Mid-Atlantic

historical political nature, so too was the range of reactions to the Party Animals. In addition, the public displays of enthusiasm, generosity, public service, devotion to community, and hard work (all of which are fundamental Washington traits), the Party Animals became fodder for classic Washington power plays. In other words, we were sued. Two weeks prior to the Party Animals hitting the streets, the Green Party sought a temporary injunction against the project, arguing that the project promoted the two-party system and excluded them unjustifiably. The Arts Commission pointed out that this was an arts project, not a political one, and the case was dismissed. A second lawsuit was filed by the People for the Ethical Treatment of Animals (PETA) because the Commission had rejected their submitted design of a brutalized circus elephant. The Arts Commission determined the PETA submission was a single-issue billboard and not up to the artistic standards of the competition.

And more lighthearted controversy was reported. There was some question as to whether the donkey had a donkey's tail, or a mule's tail. A journalist even went to a local farm to make a live animal comparison of donkeys and mules. The artist who designed the original says she knew the difference between a mule's tail and donkey's tail. We at the Arts Commission were apprised early on that any fabricator of animals would take artistic license wherever possible, especially with a tail.

It was always our view that these donkey and elephant sculptures were symbols of the political life dominating this city. But our purpose was not politically inspired. The sculptures are rounded, full canvasses upon which the artists have expressed themselves. Party Animals was about having a passion for art, not politics.

Why Public Art Matters
As public art, Party Animals defied expectations, surprising people into seeing something familiar while feeling something new. In our culture, we expect art to be housed in places apart from our daily lives, usually in our museums and galleries. But this has not always been the case—the routines of public life have often encompassed fine art. Such common objects

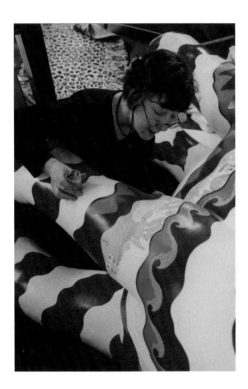

Left to right:

Le Jouet
Olivier Dupeyron

Washington Monuphant
Glennis McClellan
Atlantic Valet/Atlantic Parking

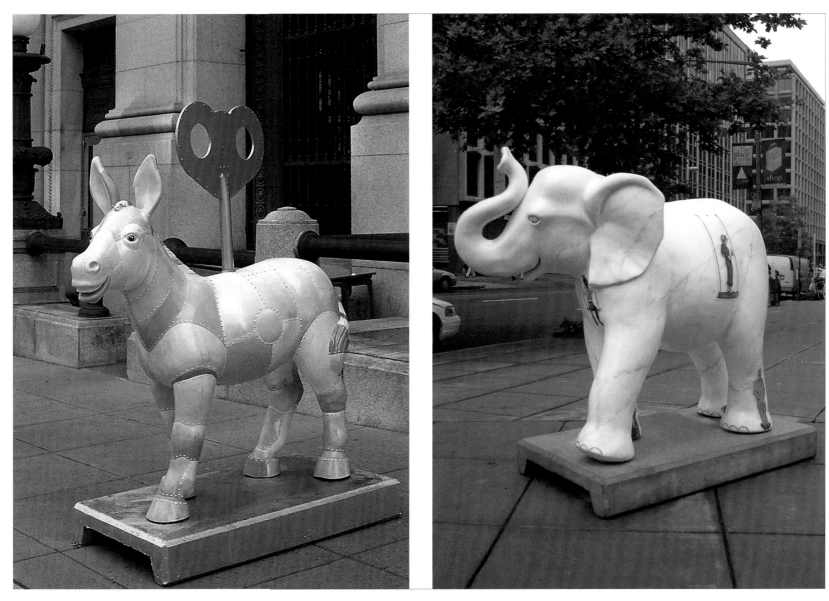

17

as the Sistine Chapel, Japanese ceramic cups and bowls, bronze religious objects in Africa, to name only a few, became fine art and people relied on them to improve and enrich their daily lives.

People in a city tend to forget how much the beautiful and unexpected mean to them. It is important for urban residents and visitors to be drawn out, pleasantly startled out of the routines of city life. It is an experience that instantaneously reorders one's perspective on art, the city, and fellow citizens, and it forces a new engagement with all three.

Party Animals has done all that we hoped for and more. For six months, they were a major part of Washington's cultural infrastructure. They have contributed to a renewed tourist interest in Washington, which, like many cities, suffered a serious downturn after the terrorist attacks on September 11th. The Party Animals helped to draw visitors back into downtown Washington and out into neighborhoods. Whole families could be observed, maps in hand, searching for the donkeys and elephants around the city. We hope that you were among the many who accepted

Mrs. Laura Bush's invitation to, "take a Party Animals safari." The Party Animals caused strangers to stop and talk about art. Consequently, the project created a public conversation about art—what it means and why it matters.

Party Animals exhibited the abundance of artistic creative talent and energy. The Party Animals public art project showed the rest of the world what Washingtonians have always known: this city's greatest riches are the imagination, resilience, devotion, generosity, and optimism of its people.

Art in public places prompts the discovery of an appetite for the whimsical among the mundane. Beauty and art can change our urban environments. Art can surprise us out of our routine pursuits. It moves us to speak to strangers about our ideas and perceptions of our shared world. People are pleased to discover that, at root, artists have the same way of thinking about things as they do. All of us move easily from the political to the comic, from the aesthetic to the analytical.

During the exhibition, the vitality of our city increased. The city felt livelier, friendlier, and more engaged with its

citizens and visitors. Beyond the temporary delight which the Party Animals gave, the exhibition continues to enrich Washington's art community. The much-needed funds raised when the sculptures were auctioned were invested back into the DC Arts Commission to fund artist's grants and arts education projects. This display of our artistic diversity and human cooperative spirit tipped the DC arts scene into a broader realm of appreciation and recognition. Party Animals was an expression of diligence, accomplishment, contribution and, ultimately, love for the city in which we live.

Dorothy Pierce McSweeny, *Chair*
Lou Stovall, *Artist and Vice Chair*
Tony Gittens, *Executive Director*
DC Commission on the Arts and Humanities

Fire in the Belly
F.L. Wall
June & John Hechinger

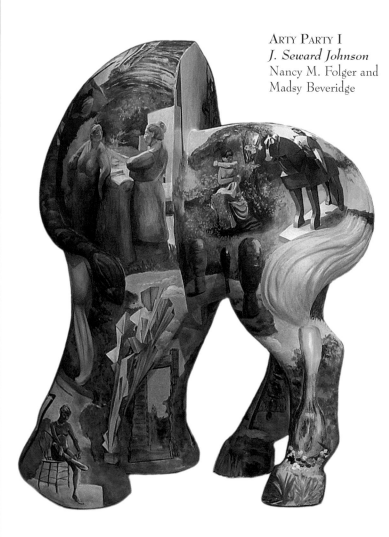

ARTY PARTY I
J. Seward Johnson
Nancy M. Folger and
Madsy Beveridge

Parable of the Donkey and the Elephant
From the Grounds for Sculpture and Sculpture Foundation
By J. Seward Johnson

The following is a list of pieces represented on the donkey/phant sculptures.

Pieces by J. Seward Johnson:

The Awakening (at Haynes Point, Washington, DC)
Dejeuner Deja Vu
Eye of the Beholder
Family Secret
If It Were Time
King Lear
Le Promenade
On Poppied Hill
Part of Nature
Sailing the Seine
The Tooth
Were You Invited?

Pieces representing sights around the Grounds:

Giverny Bridge
Lily and Belle—boats on the watercourse
Mr. Rat
Rats Caravan
Treehouse Gazebo
Two peacocks

**Pieces from the Grounds for Sculpture
and environs:**

Magdalena Abakanowicz—Sage; Sage B
James Barton—Constellation
Bruce Beasley—Dorion
Itzik Benshalom—Facing Couple
James Colavita—Bell
James Dinerstein—Canon
Carlos Dorrien—The Nine Muses
Walter Dusenbery—Porta Massa; Porta Stazzema

Horace Farlowe—Portal Rest
Leonda Finke—Standing Figure from Women in the Sun
Mary Frank—Sundial
Philip Grausman—Leucantha
Mike Gyampo—Just Chillin'
John Henry—Grand Rouge
David L. Hostetler—Duo; Summertime Lady
Luis Jiménez—Mesteño
Sterett-Gittings Kelsey—Alexandra-of-Middle-Patent
Berj Krikorian—Sparten
Jon Lash—Frame Construction #5
Wendy Lehman—Fuss-n-Feathers
Alexander Lieberman—Daedalus
Peter Lundberg—Where is Geometry?
Marisol—General Bronze
Clement Meadmore—Offshoot
G. Frederick Morante—Nude Descending the Stare Case
Robert Murray—Hillary
John Newman—Skyhook
Joel Perlman—High Spirit
Karen Petersen—The Listener
Martha Pettigrew—Gossip
Robert Ressler—Baruch Ashem; Wave Hill
George Segal—Depression Bread Line
Larry Steele—All Night Long
Dana Stewart—The Chase; Lester
George Sugarman—Doubles
Toshiko Takaezu—Three Graces
Gunnar Theel—Nature's Laugh
Herk Van Tongeren—Teatro XI
Clifford Ward—Jubilant Dancer
Gary Wertheim—The Family
Isaac Witkin—The Bathers; Garden State
Autin Wright—The Sleep

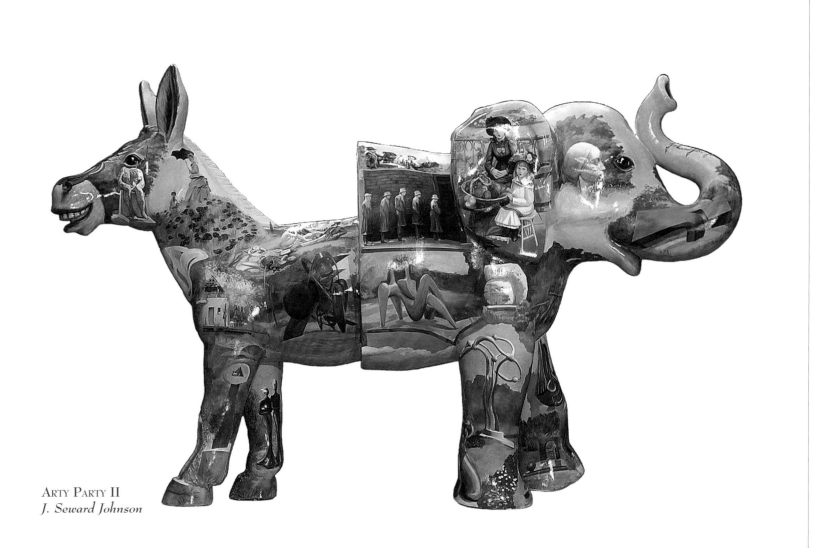

ARTY PARTY II
J. Seward Johnson

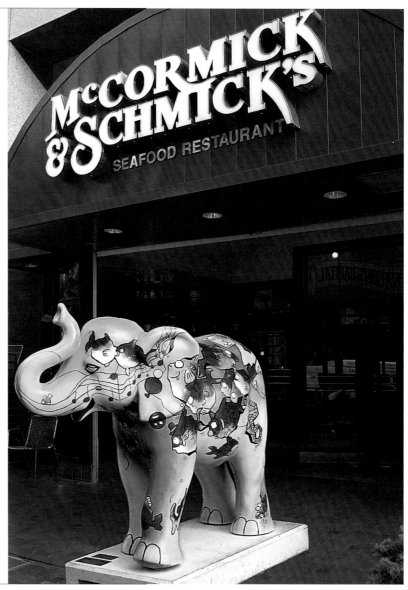

Left to right:

GRAND OLD PACHYDERM
Gary Jameson
McCormick & Schmick's
Seafood Restaurant and M & S Grill

SCHOOL PARTY
Naomi Campbell
McCormick & Schmick's
Seafood Restaurant and M & S Grill

DESTINATION DC
Jennifer Sarkilahti

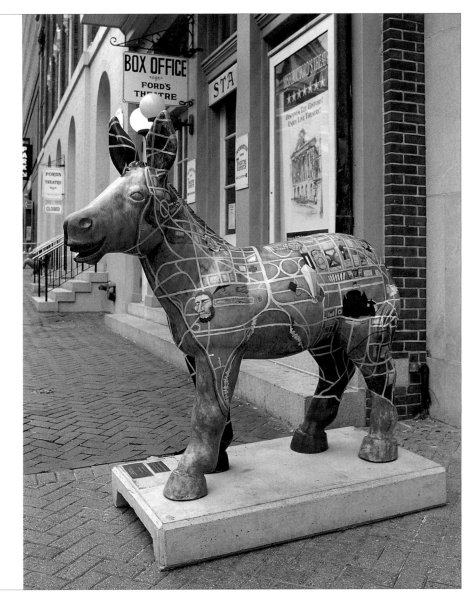

Left to right:

"AFTER PEACEABLE KINGDOM"
Lisa Farrell
Irwin Edlavitch

PHOTOTRANSISTOR
Bruce McKaig
Golden Triangle BID

PENNY
Joe Sutliff
Clyde's Restaurant Group

Left and bottom:

ELEFANTASY
Rosemary Luckett

Far and near right:

THE ROSE GARDEN
Laney Oxman

HIDDEN ASS ETTS
Gus Garcia
Hecht's

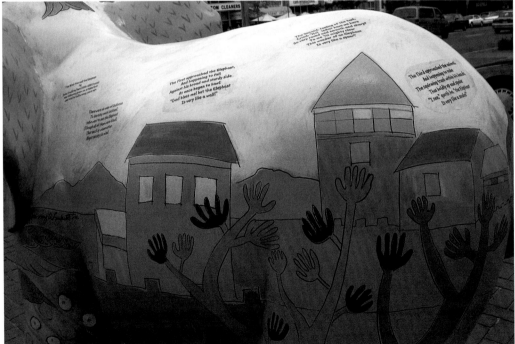

Left to right:

DREAM 2: GOD BLESS THE WORLD
Normon Greene
Accommodations Unlimited

ELEPHANT WALK
Washington Calligrapher's Guild
Linda Levine, Marta Legeckis & Pat Blair
PEPCO

BARN RAISING
Ellen Sinel
The Oliver Carr Company

AMERICA THE BEAUTIFUL
Di Stovall
The Oliver Carr Company

THE TRIUMPH OF ALTRUISM AND PATRIOTISM
Myra Maslowsky
National Air and Space Museum

THE PEACE DONKEY
Richard Blackmore

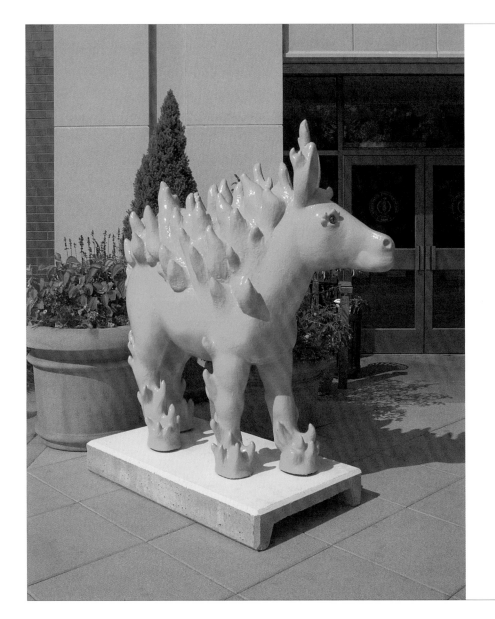

Left to right:

GREEN PARTY ANIMAL
Howard Connelly

COAT OF NAILS
John Dreyfus
June & John Hechinger

BAMBORITO
Juan Bernal
Comcast

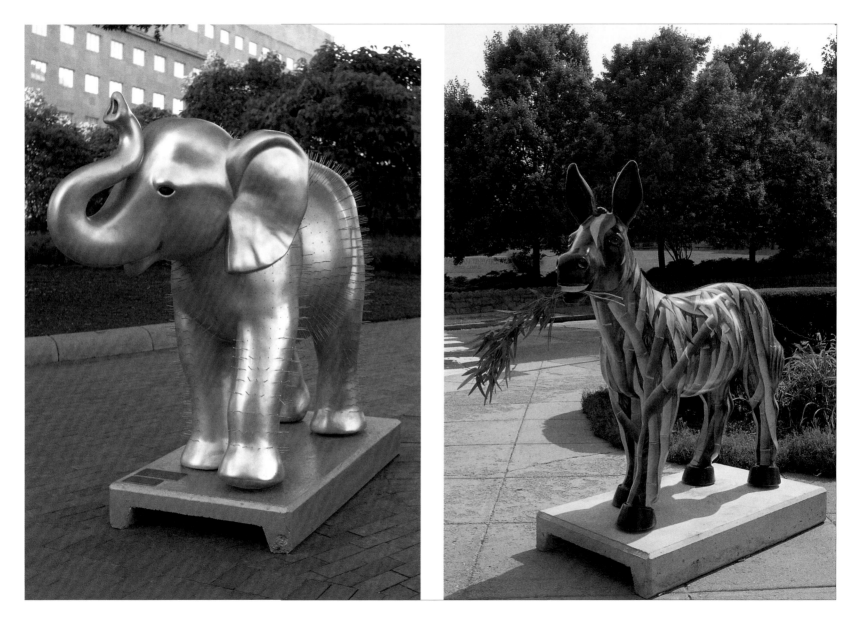

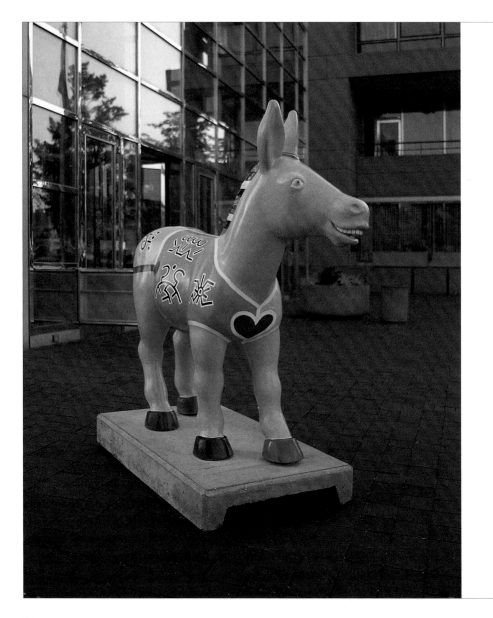

Left to right:

Mister Ioso
Tom Green

Why Do Elephants Paint Their Toenails Red?
So They Can hide In Cherry Trees
Debbie Smith Mezzetta

Azra
Maja Bality
Smithsonian Institution

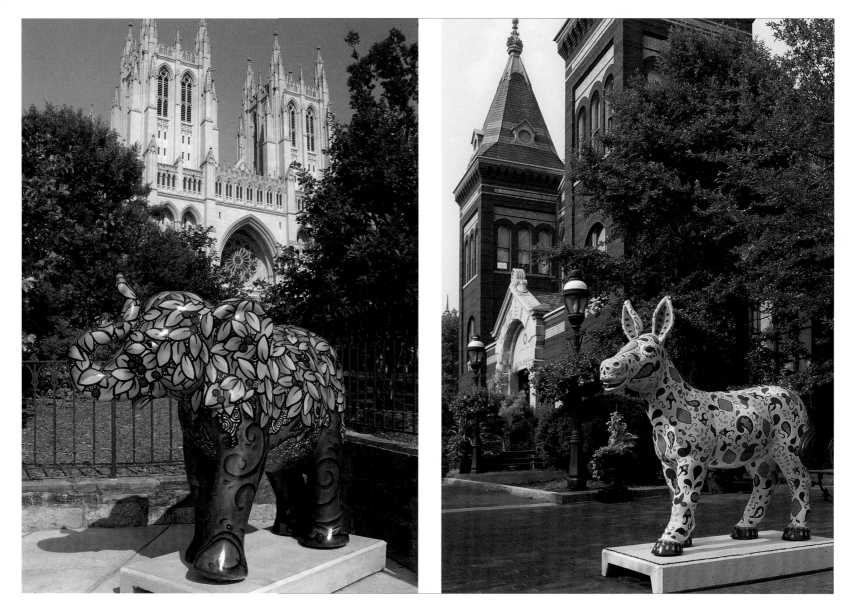

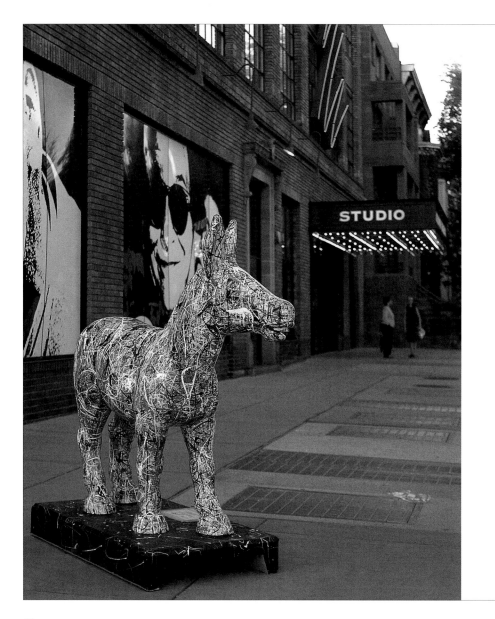

Left to right:

POLLOCK-TICIAN
Steve Walker

DONKEY OF A DIFFERENT COLOR
Elizabeth Roberts
George Washington University

OPENINGS
Banita Ambrose
Caribou Coffee

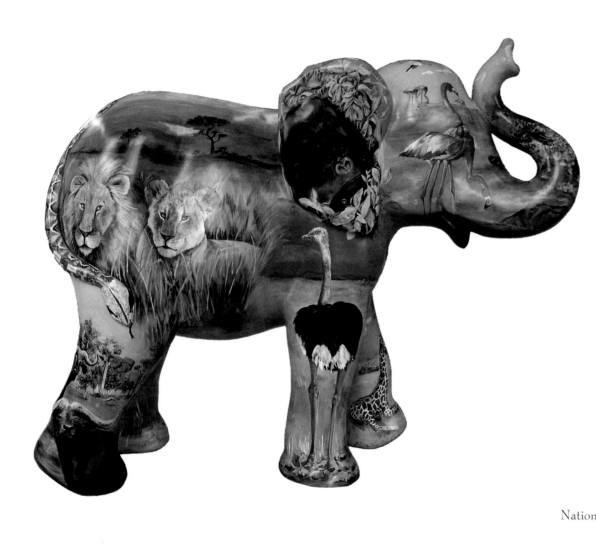

AFRICAN ELEPHANT
Melissa Daman
National Museum of Natural History

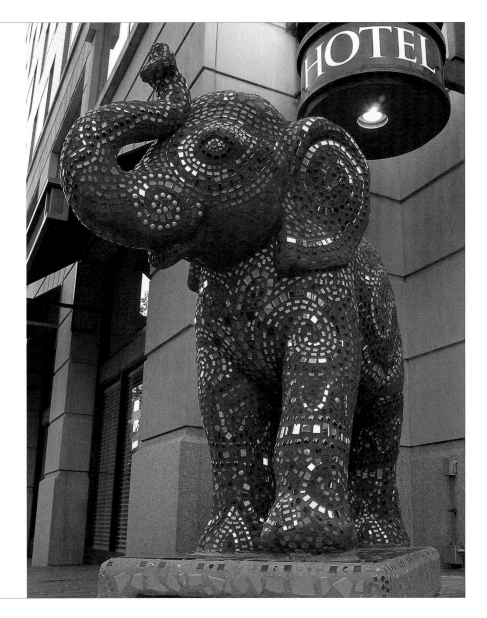

MAGIC CARPET RIDE
Marla McLean & Lamar Davis
Monarch Hotel

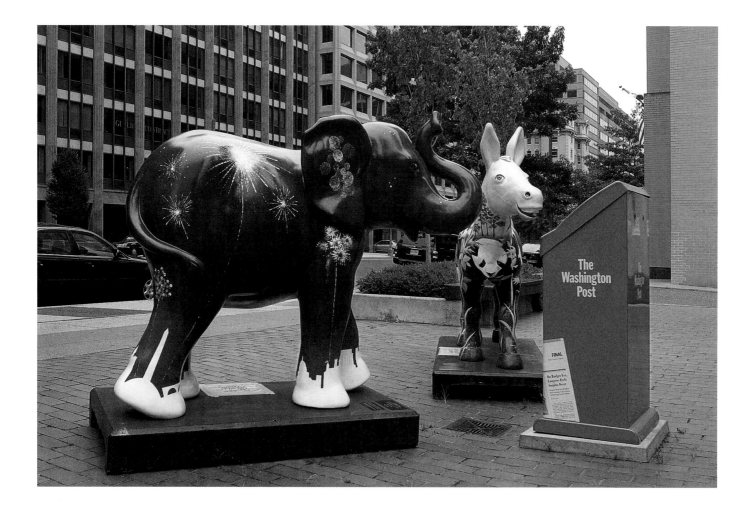

Left to right:

BLUE SKY
Betty Kubalak
The Washington Post

BABY BLUE
Caroline Afande
The Washington Post

PATCHES
Stevens Carter

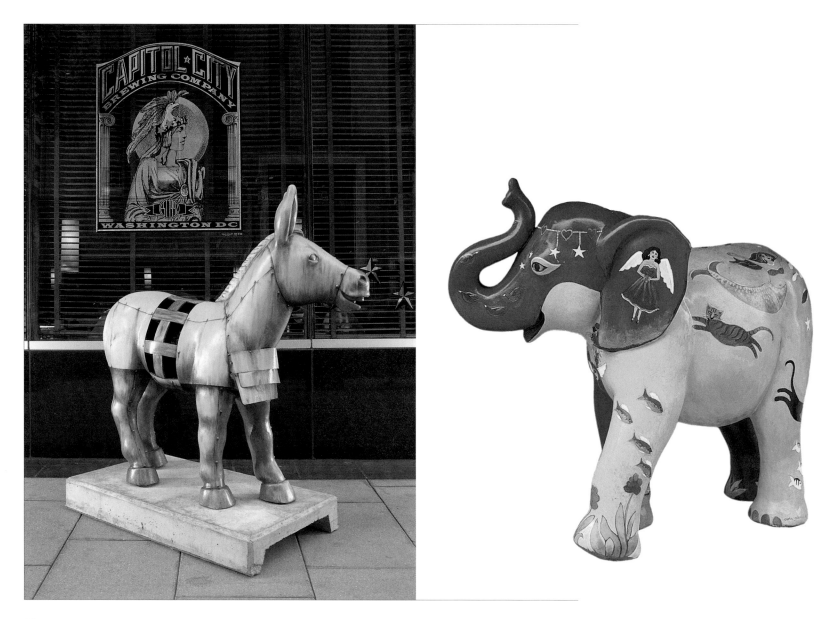

Left to right:

Lucky Don Keystadore
Melissa Shatto
Capital City Brewing Company

Elephant of Infinite Dreams
Carla Golembe
Wyndham Washington Hotel

Spirit Bird Riding High
Joan Danziger
MarcParc Inc.

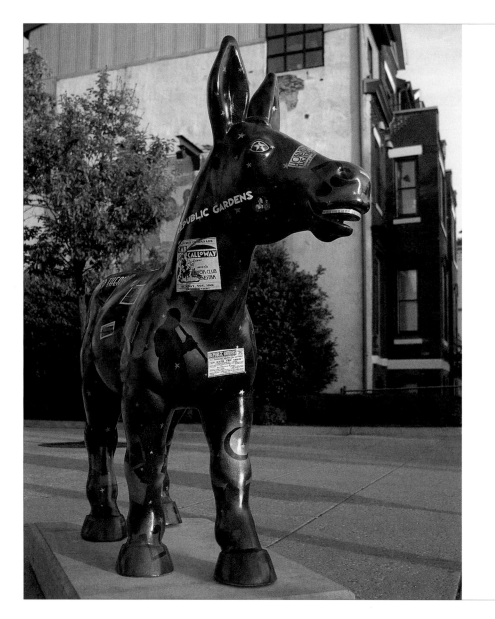

Left to right:

JAZZIN' ON U STREET
Kelly Talbott

GOPOLY
Noelle Zeltzman
The Bernstein Companies

JUST VISITING
Mary Fran Miklitsch
Fleishman-Hillard Inc.

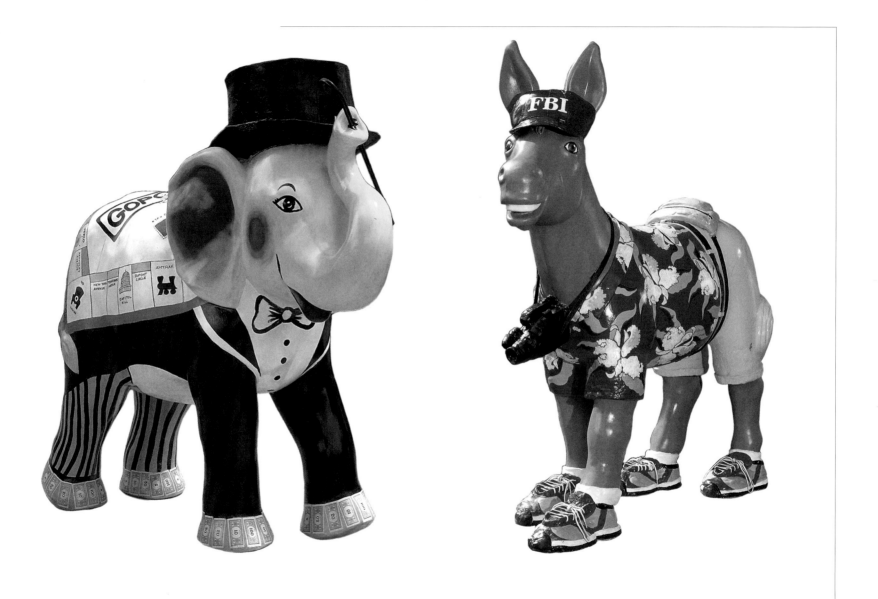

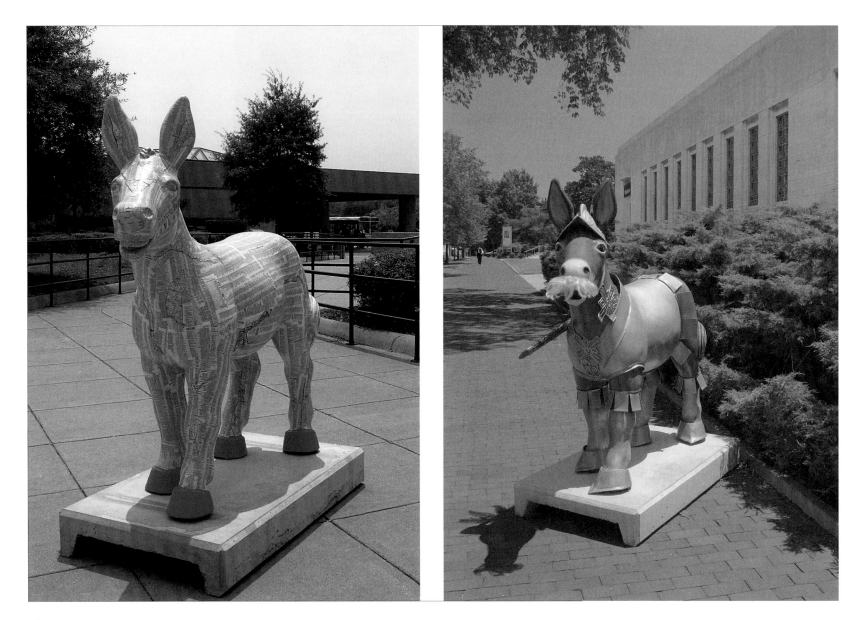

Left to right:

DONKEYTOURIST
Annette Jones
Fannie Mae and
The Fannie Mae Foundation

DONKEY OTE
Denise Hooe

DOG FIGHT
Steven Fuchs
Grand Hyatt Washington

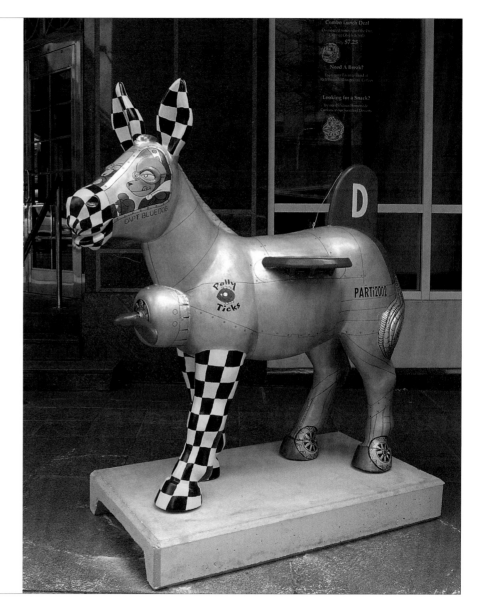

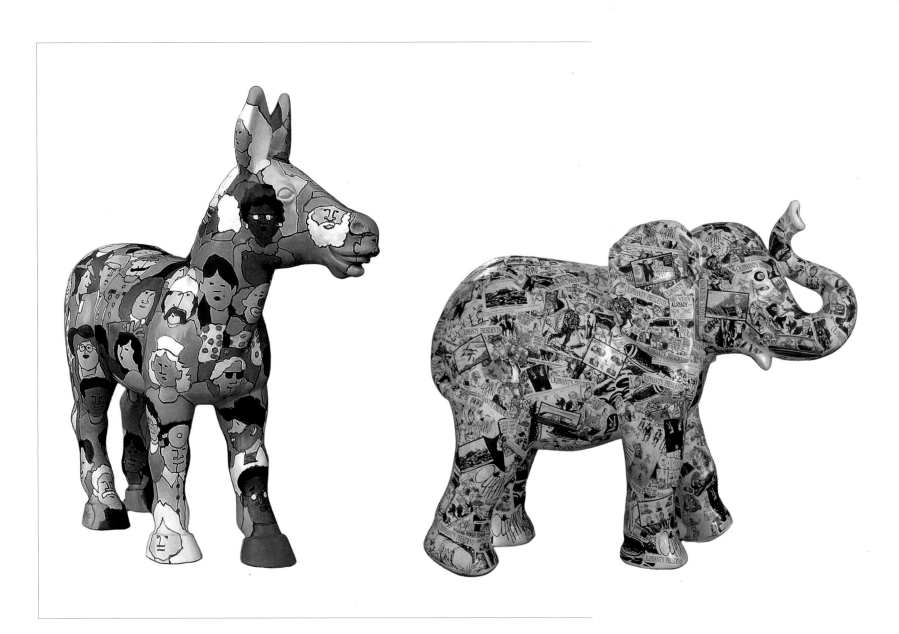

Left to right:

We The People
Sam Dixon
Washington Metropolitan Area Transit Authority

Oliphant
Kathryn Evans
Sarah Loffman
Tess Mann
Katherine Murphy
Jennifer O'Keefe
Smithsonian American Art Museum and
The National Portrait Gallery

Midsummer Night's Dream
Kristen Parker
WETA TV26 & 90.9FM

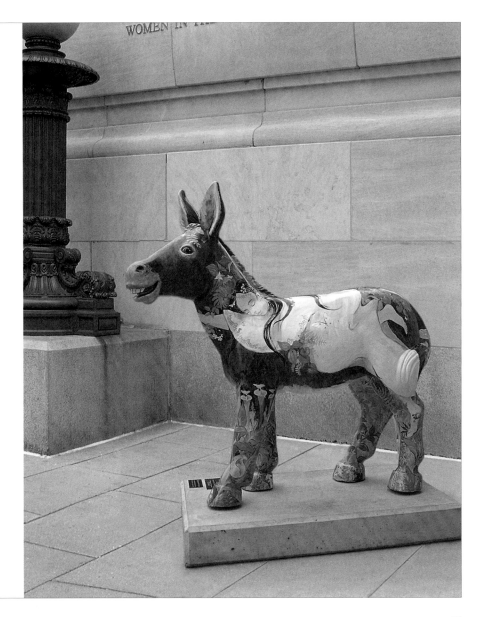

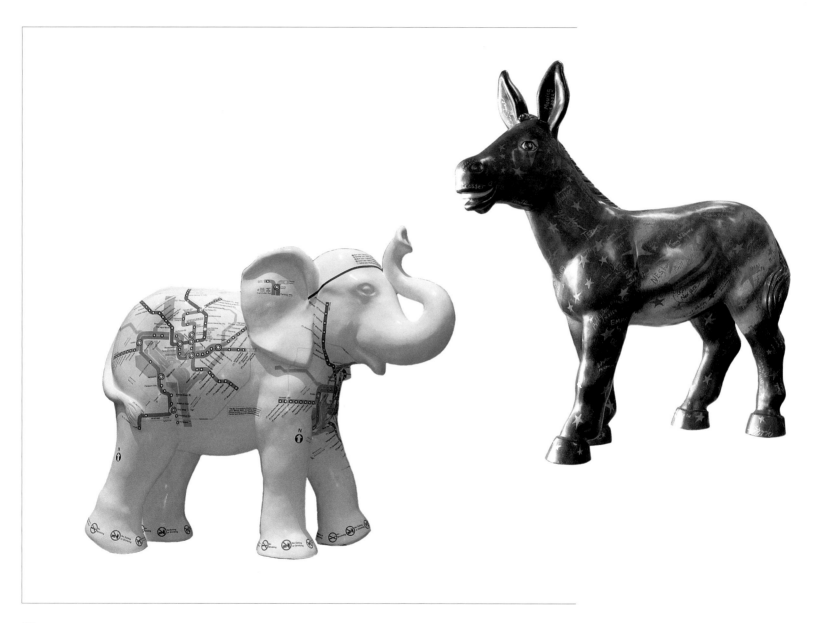

Left to right:

METROPHANT
Robyn Rogers
Golden Triangle BID

UNION JACK
Michael Carr & Sierra Nicole Riddle
Forest City Entreprises, Kaempfer Company,
Bresler & Reiner

HELIANTHUS ELEPHANTHUS
Irene Clark
2000 Penn Retail Merchants

FREE SPIRIT
Nancy Sims
2000 Penn Retail Merchants

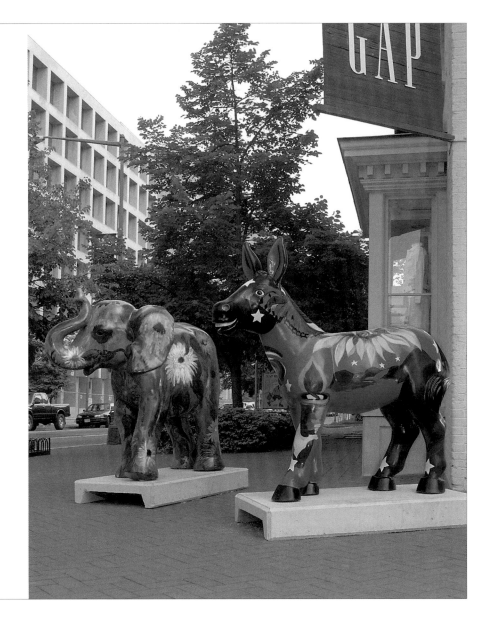

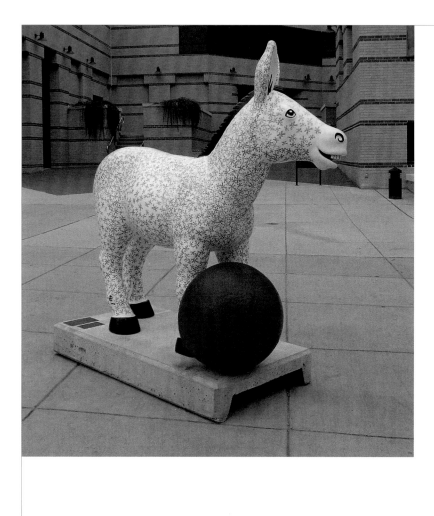

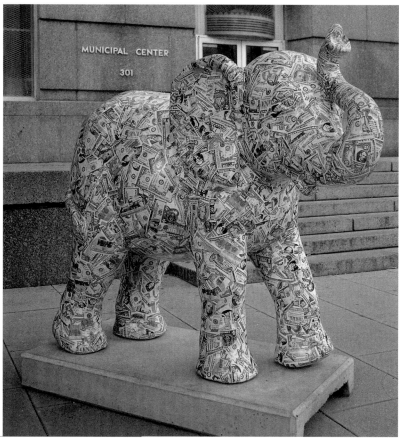

Left to right:

JACK ASS
Emily Tellez

PUT YOUR MONEY ON A WINNER
Dorothy Drumm

PARTY ANIMAL
Dickson Carroll
Greenfield Belser

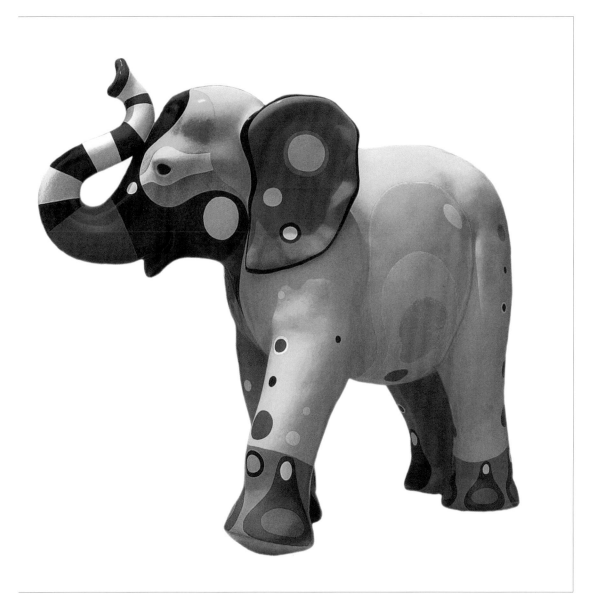

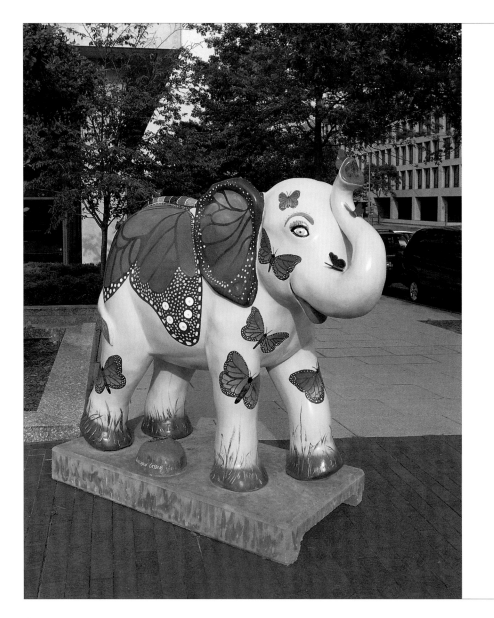

Left to right:

MONARCH BUTTERFLY ELEPHANT
Jude Andreason

BOTANICAL KANDULA
Karen Casey
Smithsonian Institution

DONKEY IN A DESERT SOUTHWEST SHIRT
Janet Gohres
Washington Convention & Tourism Corporation

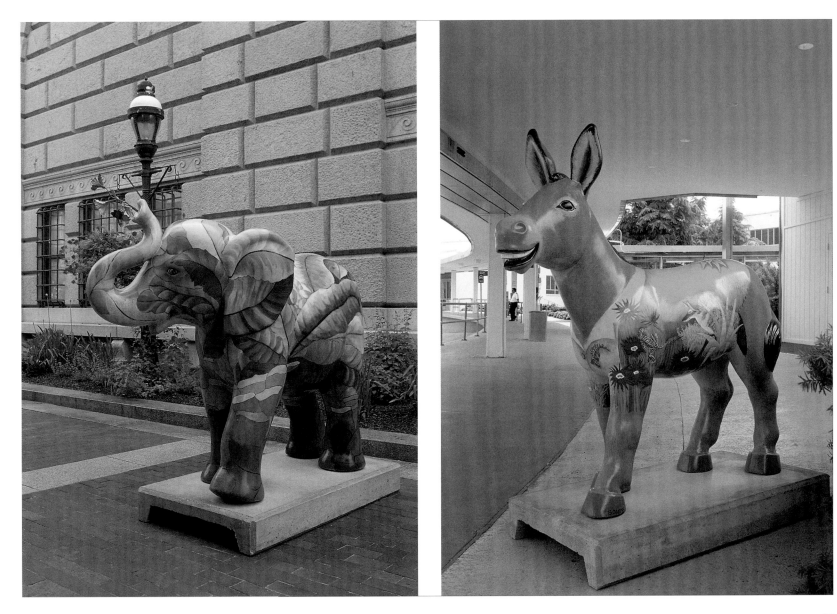

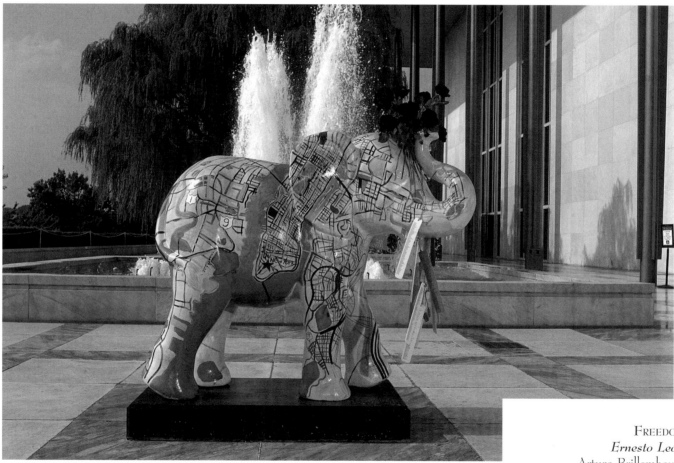

FREEDOM
Ernesto Leon
Arturo Brillembourg

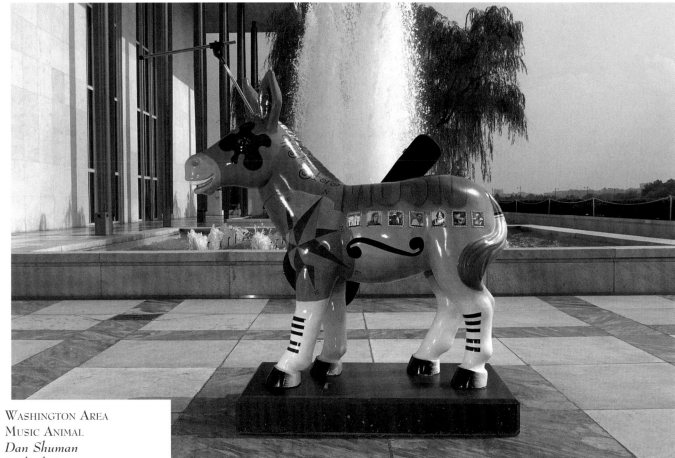

WASHINGTON AREA
MUSIC ANIMAL
Dan Shuman
Michael Brewer

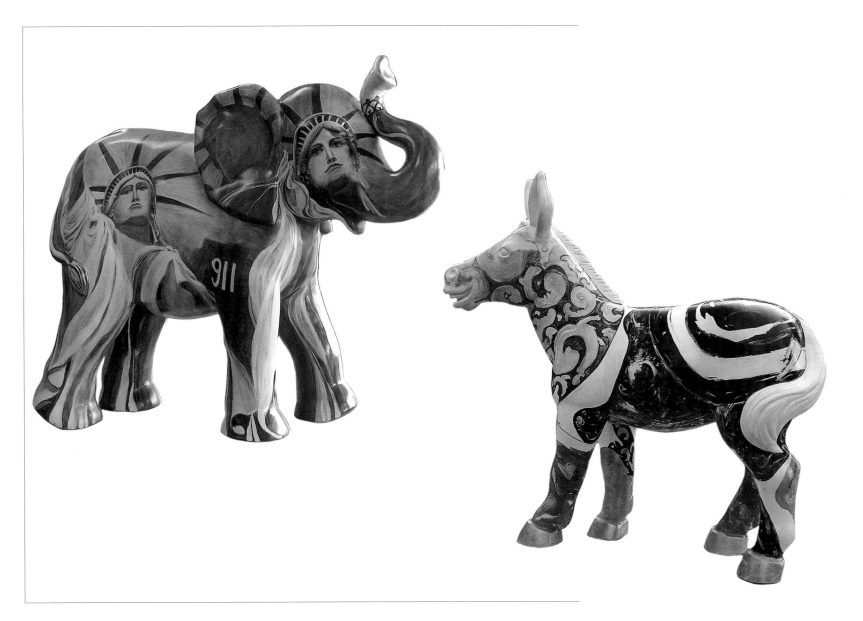

Left to right:

ELEPHANT-ECHOES OF LIBERTY
Kay Jackson
Forest City Enterprises, Kaempfer Company,
Bresler & Reiner

MY SMALL DONKEY FROM LAMBARD
Oscar Centurion

HERE'S LOOKIN' AT YOU KID
Nightbird
Black Entertainment Television

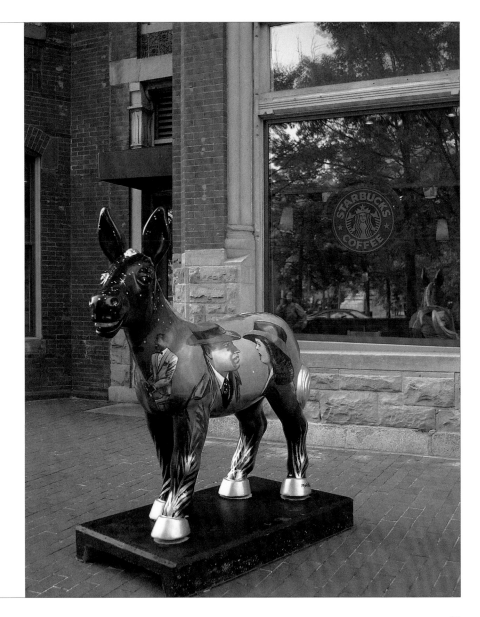

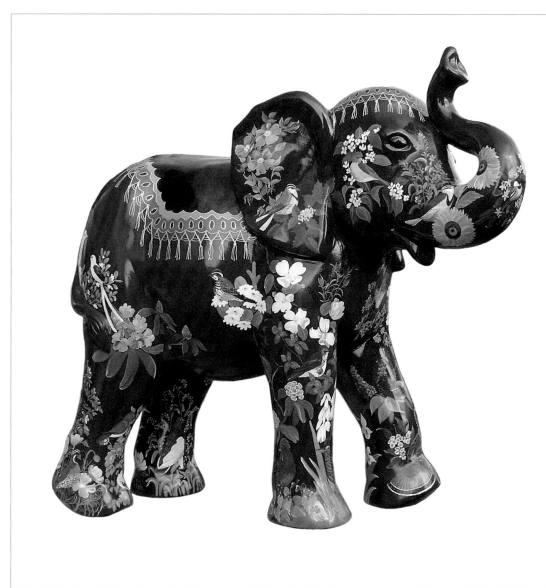

Left to right:

50 FEATHERED FRIENDS AND FLOWERS
Rufus Toomey
washingtonpost.com

BORRICO RICO
Sophia Gawer-Fische
Washington Convention Center Authority

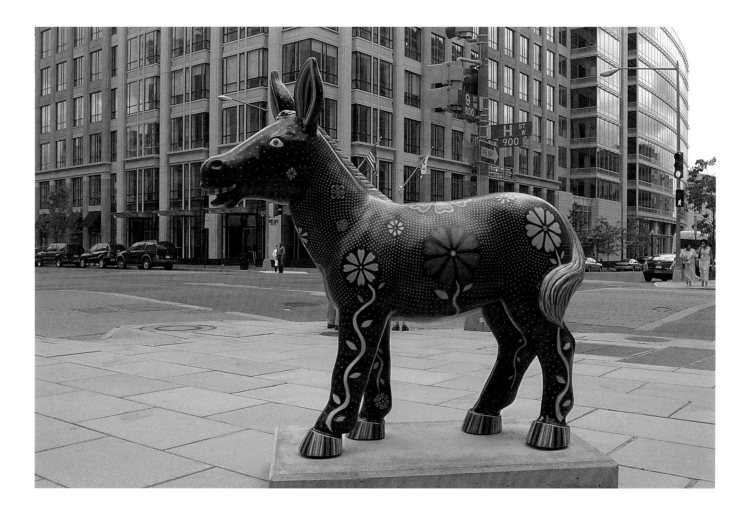

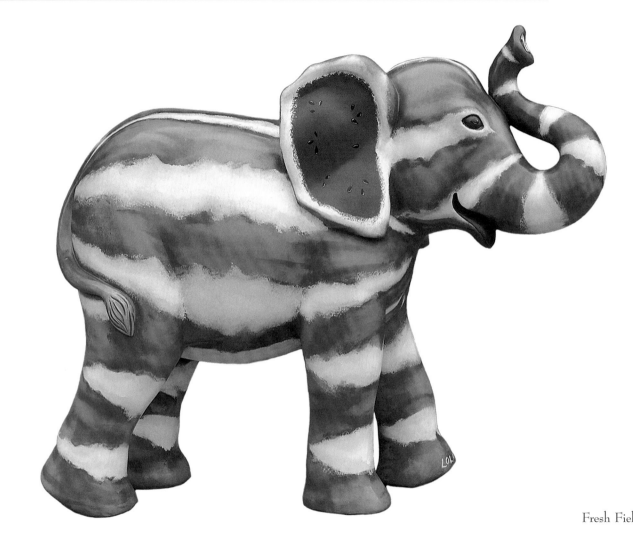

WATERMELLOPHANT
Lola Lombard
Fresh Fields/Whole Foods Market

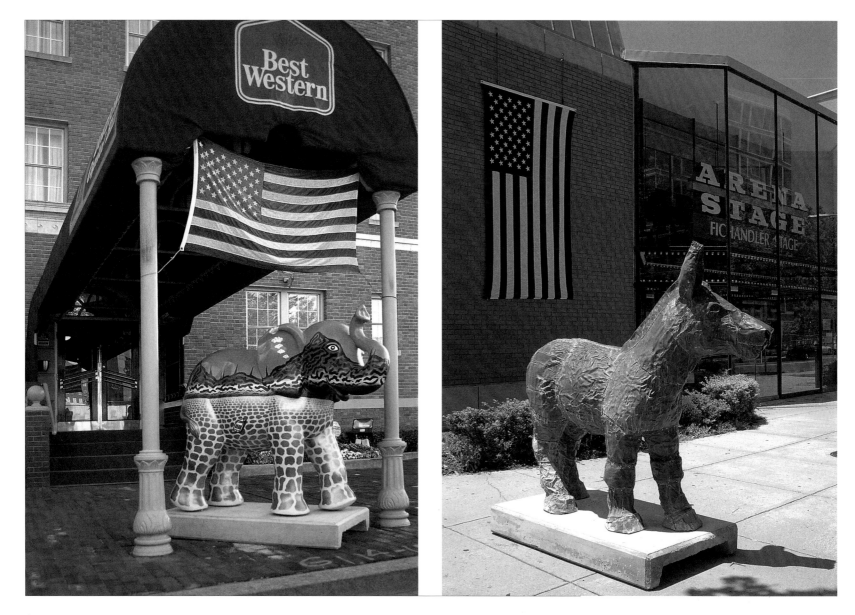

Left to right:

CRUSADER ELEPHANT
Jonathan West
Best Western Downtown-Capitol Hill

LEAD DONKEY
Jonathan Bucci

SUNFLOWER, THE PAISLEY ELEPHANT
Aimee Jackson
Kimsey Foundation

AWARENESS DONKEY
Dorothy Donahey

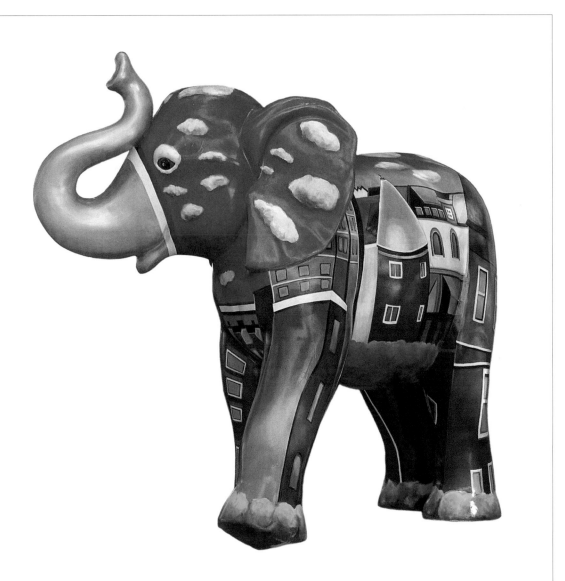

CITIPHANT
Anne Marchand

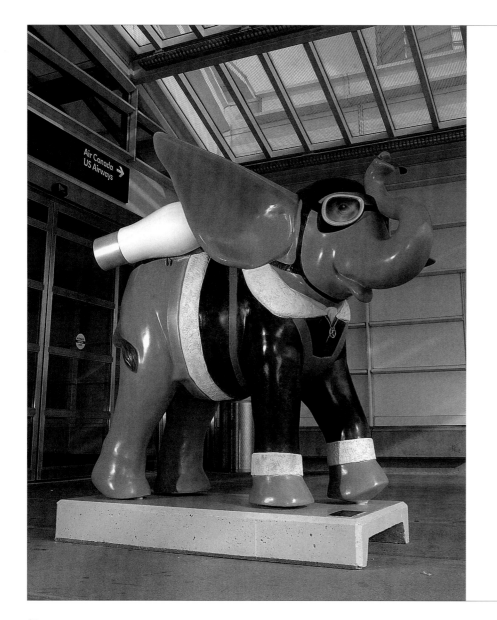

Left to right:

BUSH PILOT
Tim Scheirer
US Airways

TWO NUDED ELEPHANT
Phillip Pearlstein
Kimsey Foundation

RED TAPE
Steve Koczara

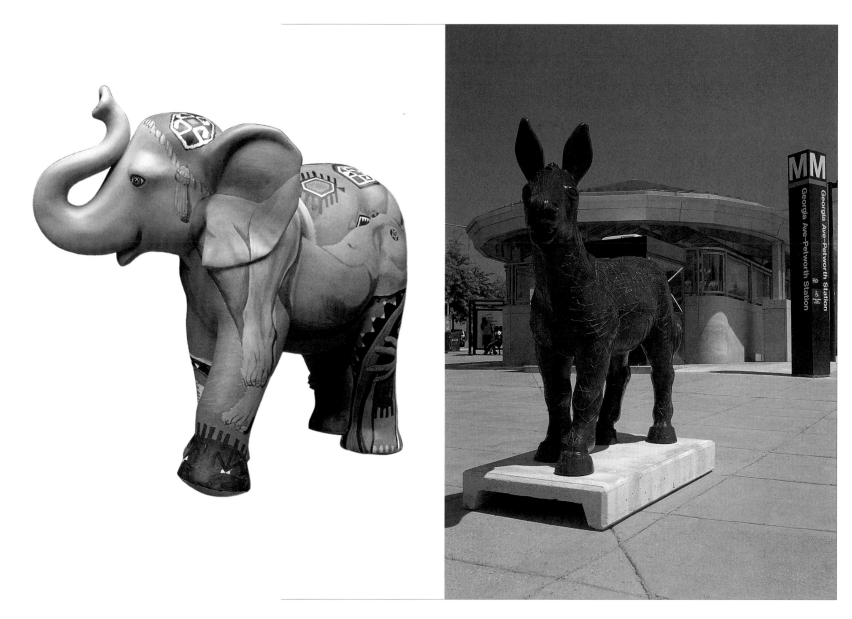

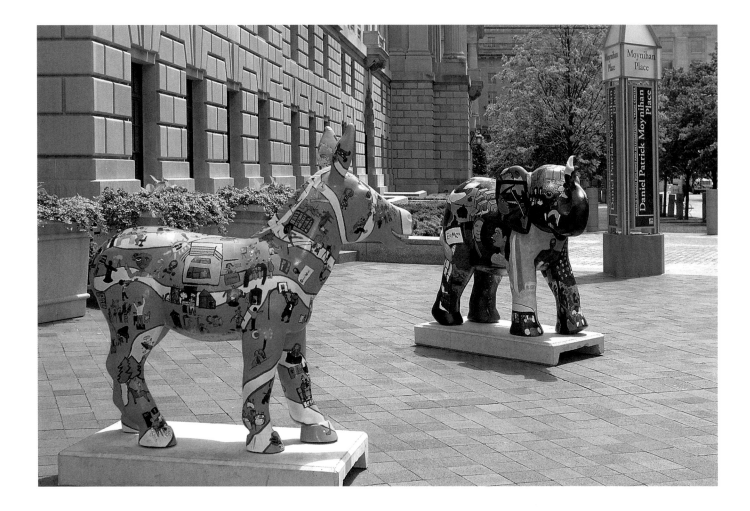

Left to right:

ASSOCIATIONS: AVENUES TO ADVENTURE
Roberta Jeffries
ASSOCIATION TRENDS
Boys and Girls Clubs of Greater Washington
Greater Washington Board of Trade
Greater Washington Society of Association Executives

ASSOCIATIONS BUILD AMERICAN DREAMS
Gary Coletrane
ASSOCIATION TRENDS
Boys and Girls Clubs of Greater Washington
Greater Washington Board of Trade
Greater Washington Society of Association Executives

CHERRY BLOSSOM DONKEY
Roberta Marovelli
Greenfield Belser

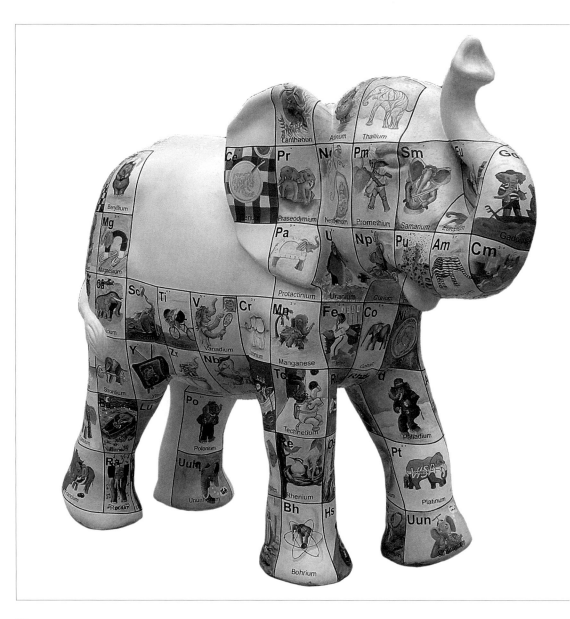

Left to right:

PERIODIC TABLE OF ELEPHANTS
Patapsco High School
American Chemical Society

DONKEY HOTEY
Arlette Jassel
washingtonpost.com

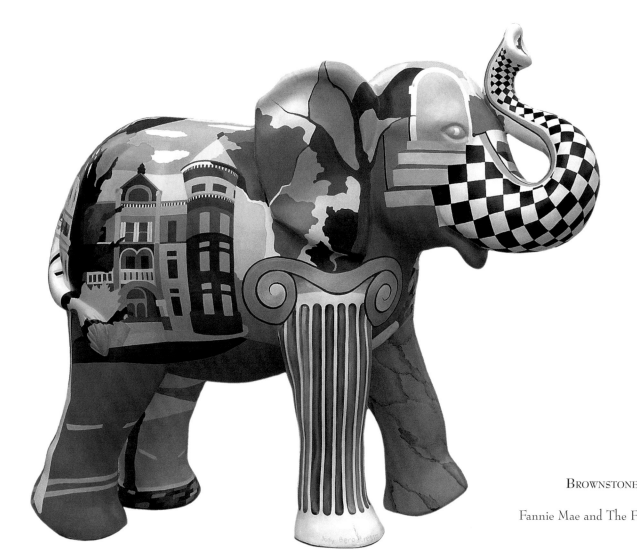

BROWNSTONE, MARBLE, AND TREES
Jody Bergstresser
Fannie Mae and The Fannie Mae Foundation

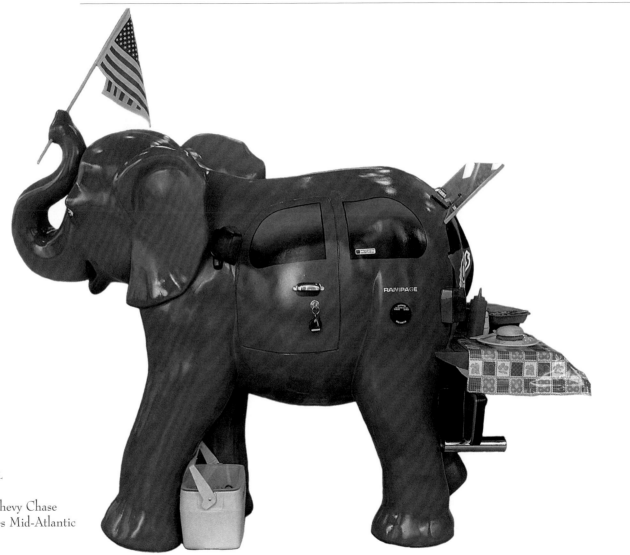

TAILGATE PARTY ANIMAL
Rachel & Bob Allen
Embassy Suites at the Chevy Chase
Pavilion Lowe Enterprises Mid-Atlantic

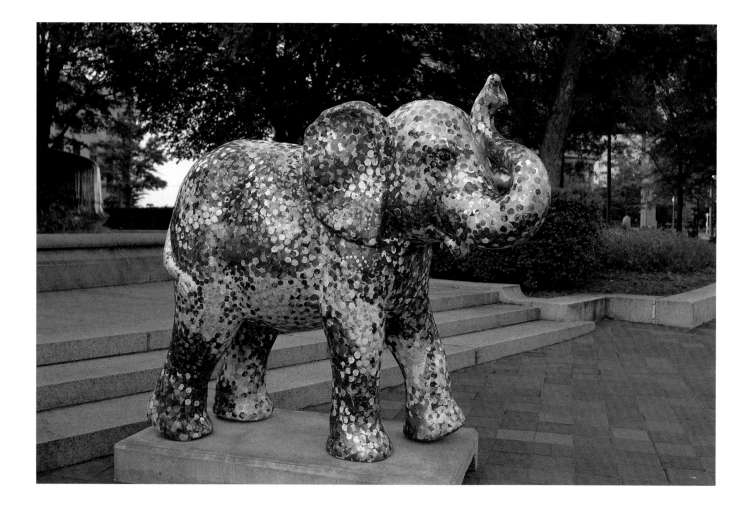

Left to right:

SEURAT
Sam Gilliam
National Gallery of Art

MELTING POT DEMOCRAT
Annette Polan
National Museum of Natural History

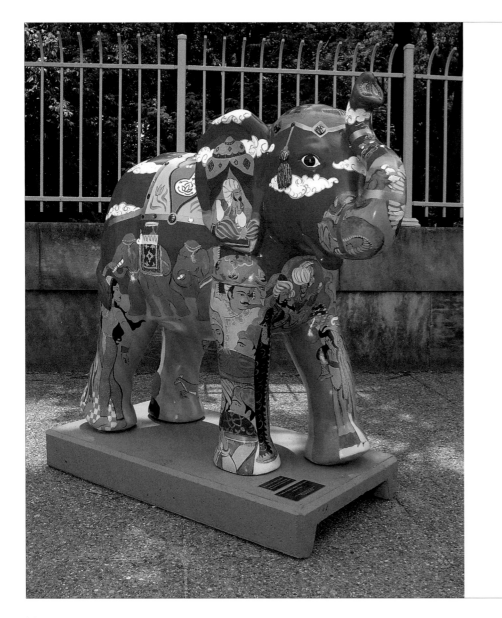

Left to right:

A GARDEN OF EARTHLY DELIGHTS:
PERSIAN FANTASY
Katherine Kahn

TWO TALES OF A CITY
Leni Stern
Democratic National Committee (DNC)

TWO TALES OF A CITY
Louise Sagalyn
Republican National Committee (RNC)

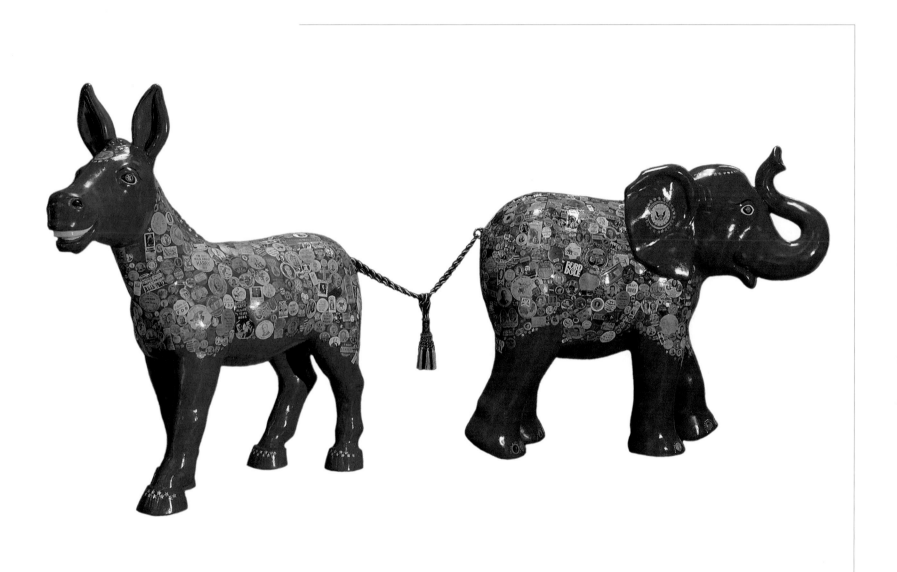

Left to right:

CAPITOL WINDOWS
Byron Peck

SALVADOR DONKEY
Rutledge Home School

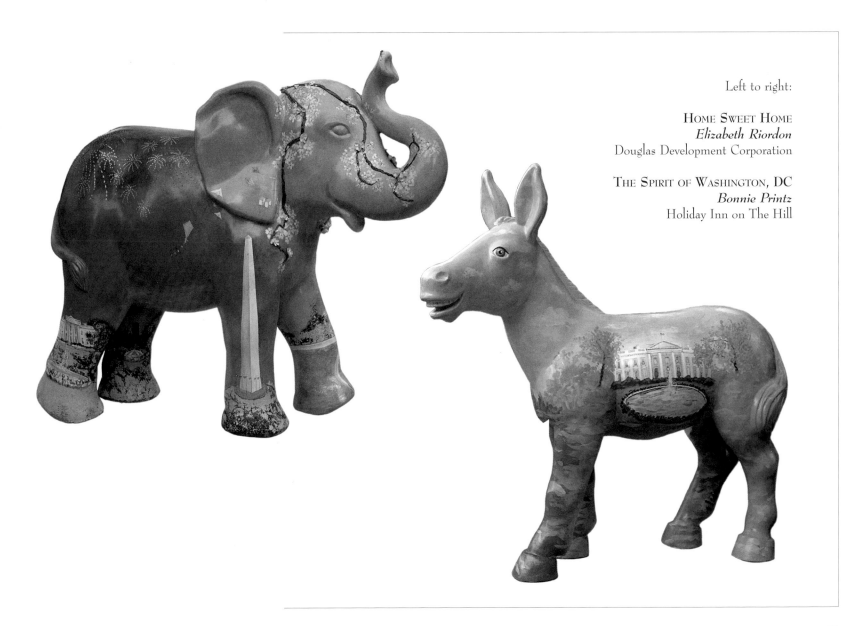

Left to right:

HOME SWEET HOME
Elizabeth Riordon
Douglas Development Corporation

THE SPIRIT OF WASHINGTON, DC
Bonnie Printz
Holiday Inn on The Hill

Left to right:

DONKEFANT-REPUBLICRAT
Beverly Ress
The Phillips Collection

AMAZEING!
Dustin Smith

NIGHT AND DAY ELEPHANT
Gail Gorlitzz
Washington Convention Center Authority

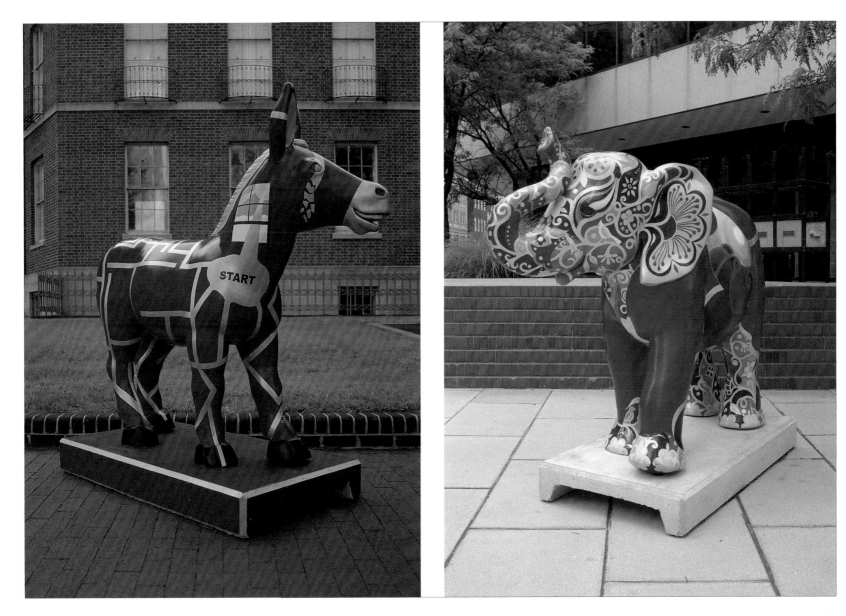

Left to right:

GARDEN PARTY ANIMAL
Judith Benderson
Accommodations Unlimited

PARTY LINES
Joseph Barbaccia
The Bernstein Companies

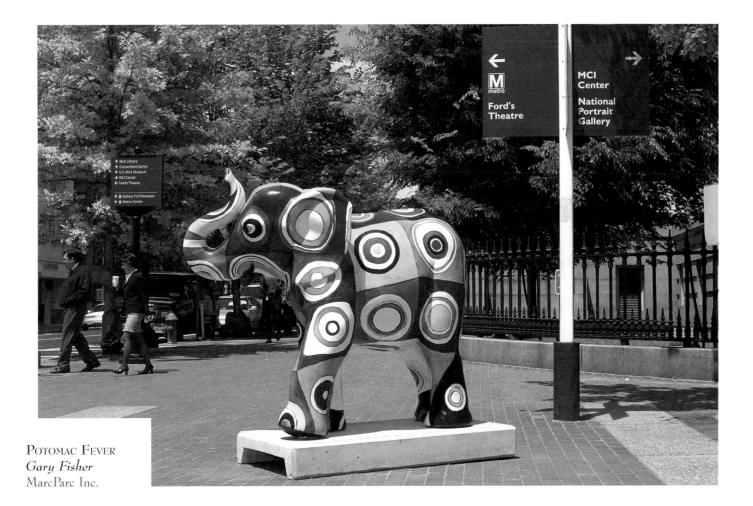

Potomac Fever
Gary Fisher
MarcParc Inc.

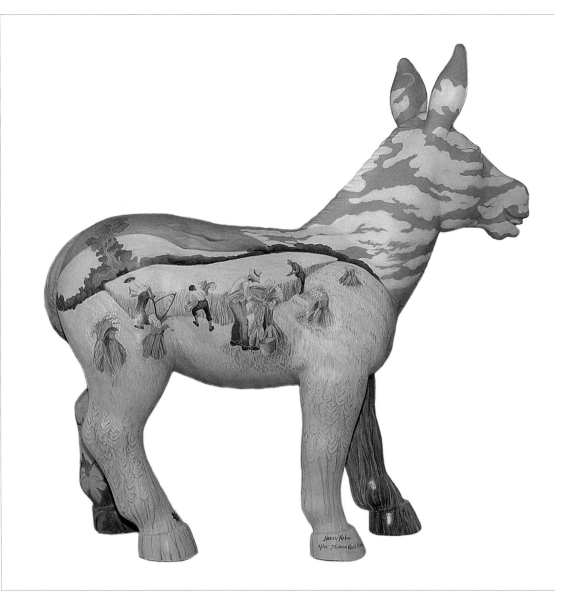

Left to right:

WORKER'S ASS et
Nancy Nahm
Kimsey Foundation

DONKEY FRACTALS
Shirley Koller
Kimsey Foundation

UNITED WE PUSH HIGHER
Joel Traylor
InterAmerican Development Bank
Cultural Center

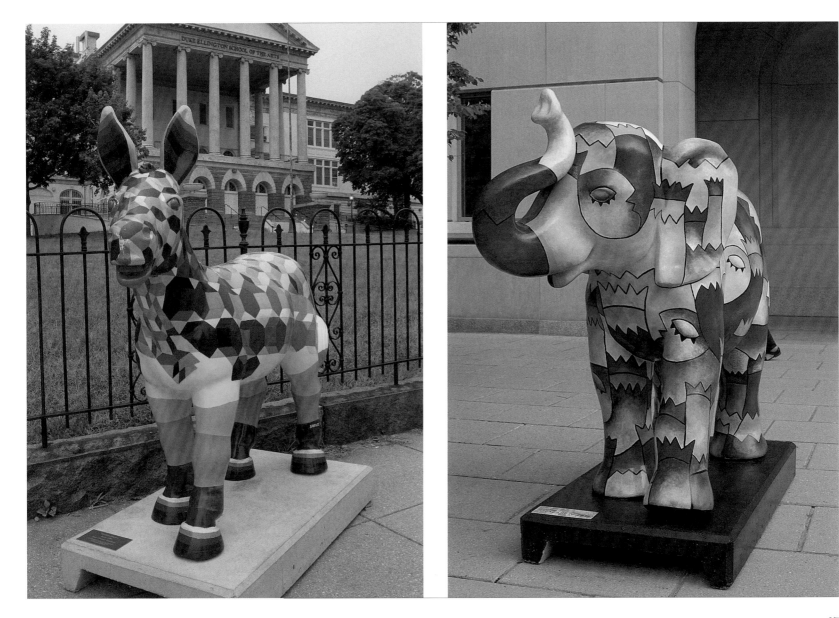

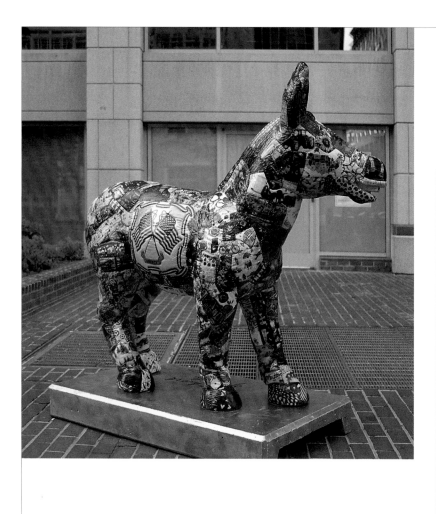

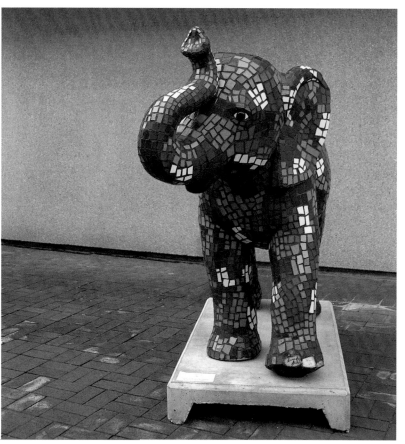

Left to right:

A PATCHWORK OF PEOPLE
Mary Beth Bellah
Park Hyatt Washington

IN A GLASS OF ITS OWN
Sara Fisher
Holiday Inn Capitol

PROFILES IN COURAGE-
TRIBUTE TO OUR HEROES
Ignacio Gomez
Lerner Enterprises-
The Bernstein Companies-
Consortium Capital, LLC

Left to right:

PARTY OF THE PEOPLE
Francesca Britton, Banneker High School
Robert M. Fisher Memorial Foundation

WE WILL WIN
Robert Alston

BLUE REFLECTIONS
Chary Robbins
National Gallery of Art

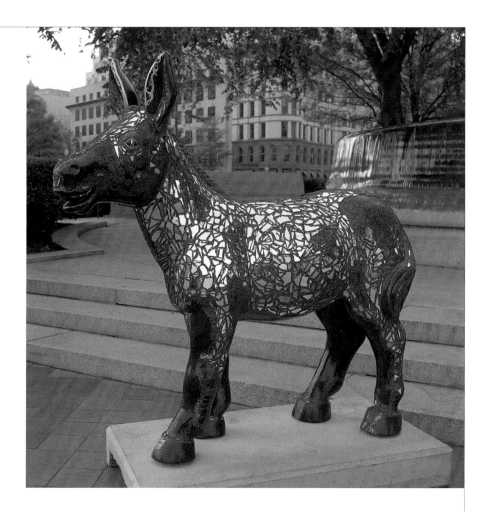

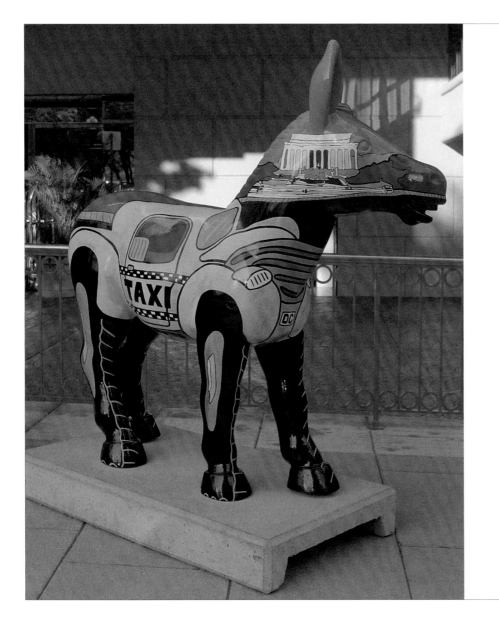

Left to right:

POTOMAC EXPRESS
Michael Anthony & Sarah Barnes
Renaissance Washington DC Hotel

ELLA PHANTSGERALD
Kathleen Carlson

EXPLORING
Allison Miner
National Air and Space Museum

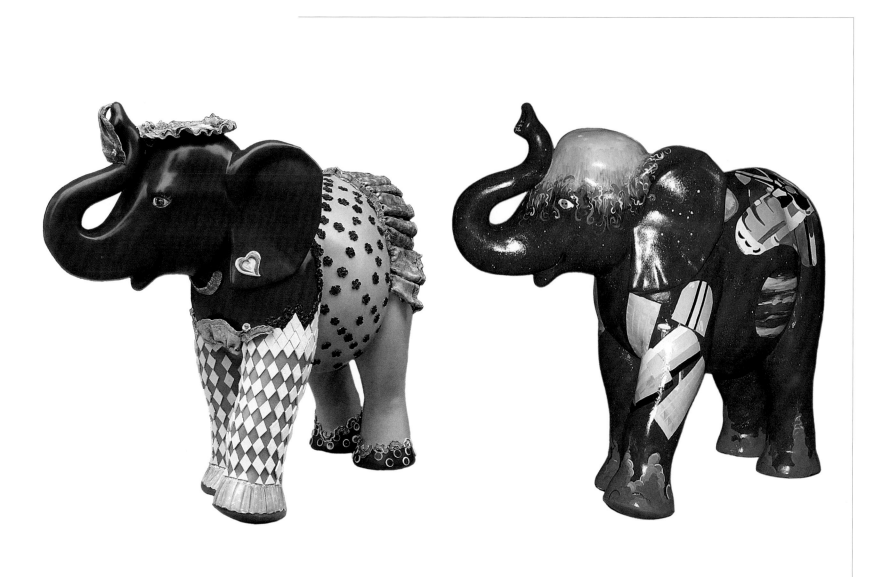

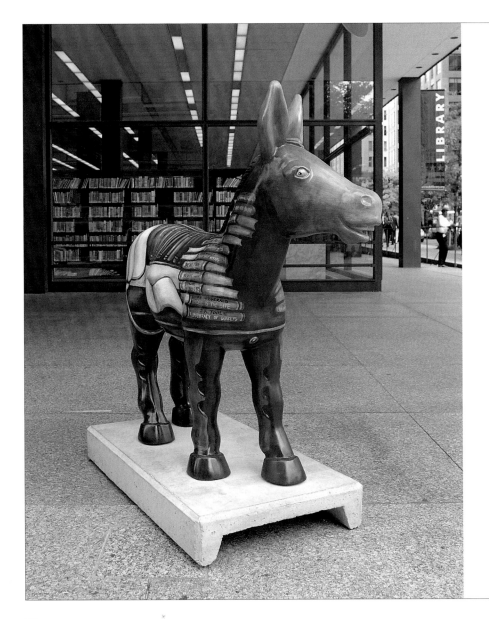

Left to right:

CLEVER DONKEY
Zora Janosova
Perseus Books Group

OUR WORLD
Dianne Bugash

ENVIRO DONKEY
Claudia McElvaney
PEPCO

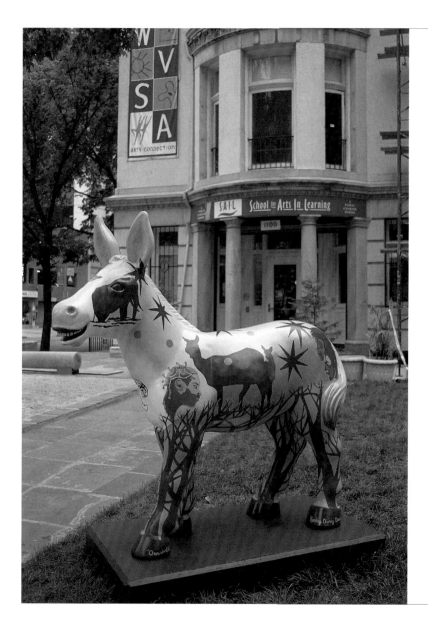
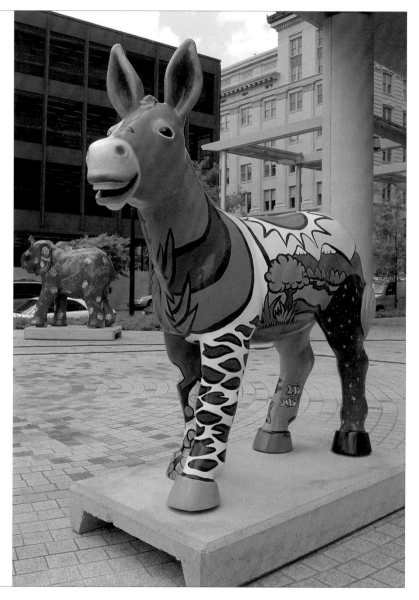

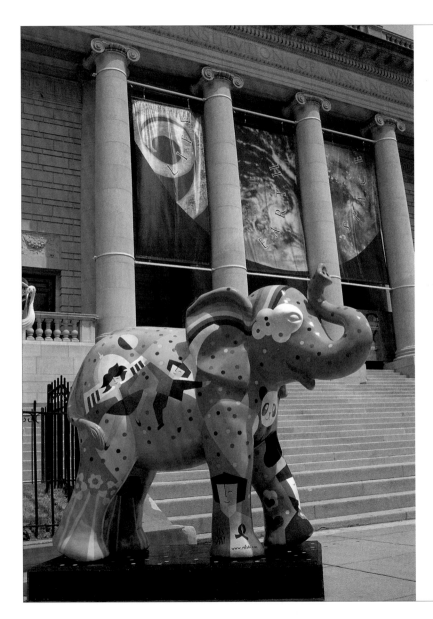

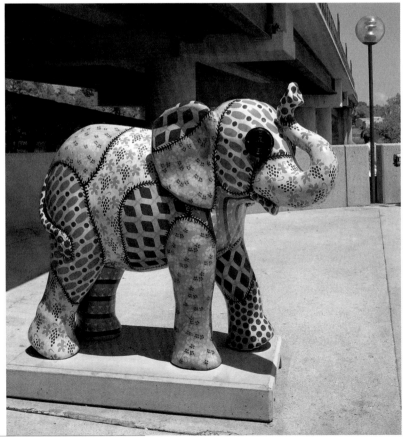

Left to right:

PIERRE L'FANT'S CAPITAL PARTY
Nicolas Shi
Suellen & Melvyn Estrin

CALICO ELEPHANT
Jerry Arnold

STROM
Chad Alan & His Friends
National Geographic Society

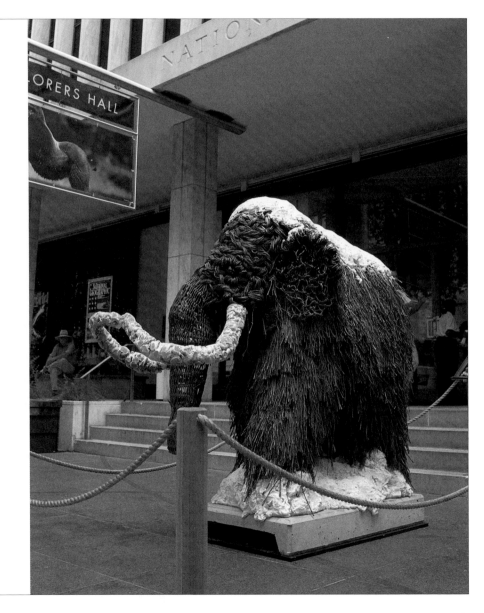

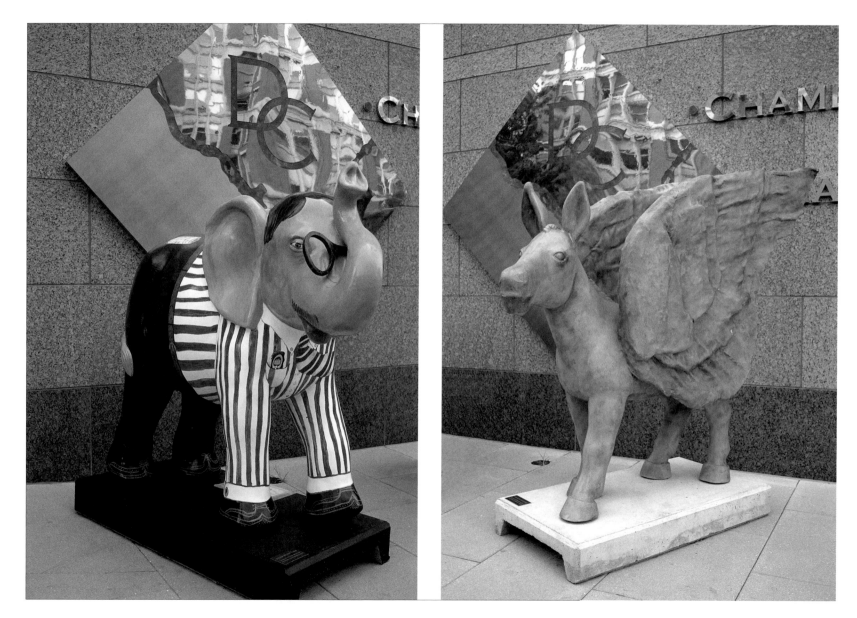

Left to right:

L.E. PHANT, ATTORNEY AT LAW
Theresa Knight McFadden
DC Chamber of Commerce

PEGASSASS
Mina Marafat
DC Chamber of Commerce

DREAM TIME IN AN ELEPHANT
Jeanne O'Donnell

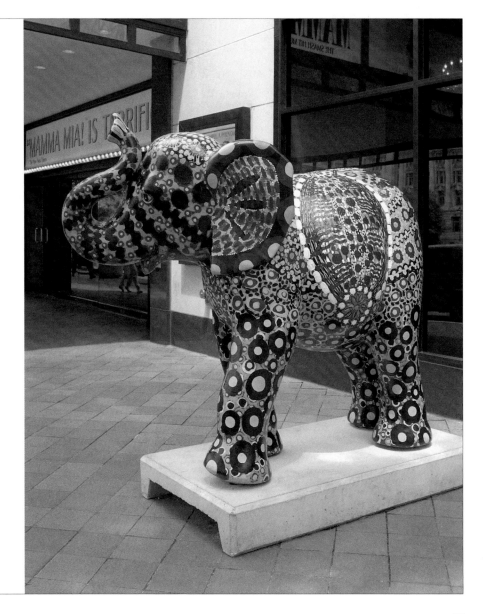

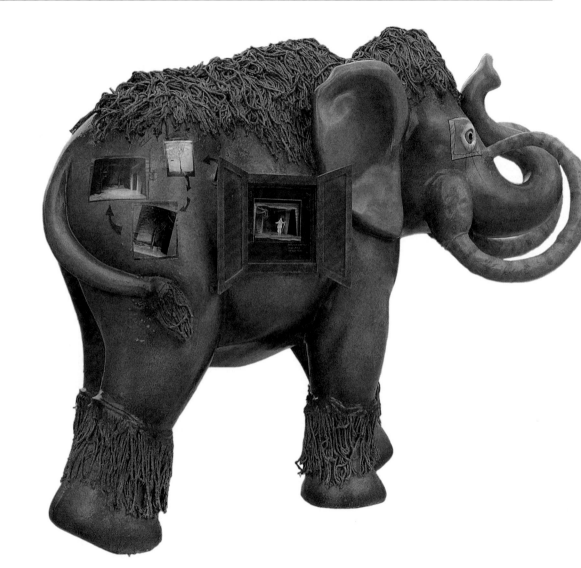

Left to right:

MAMMOTH MAGIC
Woolly Mammoth Theatre Company

STREET CORNER HARMONY
Cedric Baker
Carr America Urban Development, LLC

MUSICAL ELEPHANT
Konstantin Tikhonov

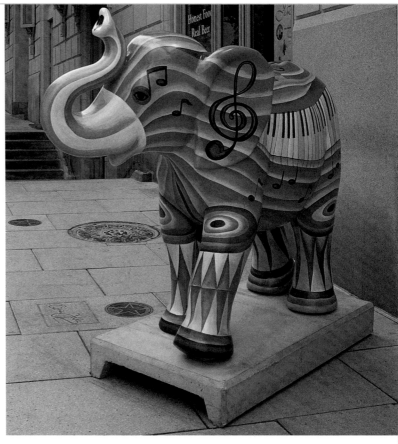

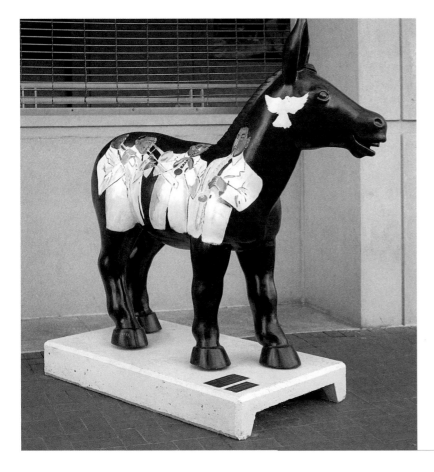

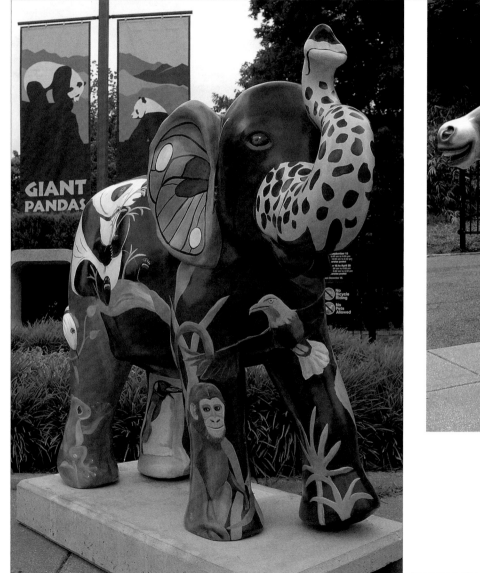

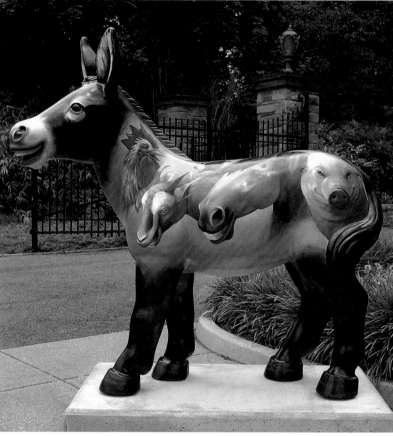

Left to right:

PANORAMIC PACHYDERM
Jody Wright
Horning Brothers

LAUGHING STOCK
Phyllis Saroff
Ronald Brown Foundation

I HAVE A DREAM
Community of Hope

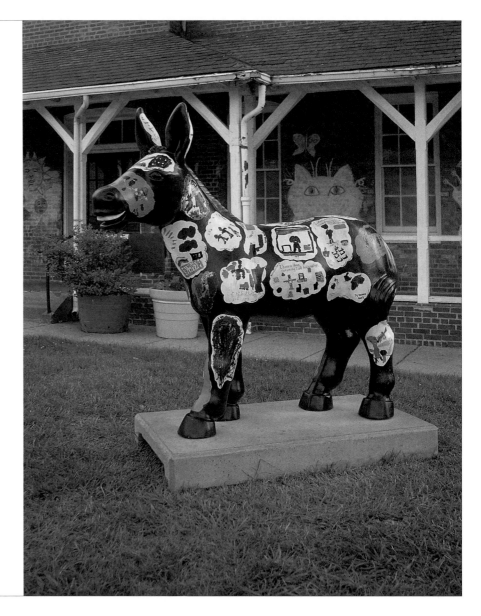

Left to right:

PACHYDERM PARCEL
Robin Hummel
Capital City Brewing Company

SPECIAL DELIVERY
Jayson Swafford

SMARTICUS PANTICUS
Glennis McClellan
Perkins Coie LLP Political Law Group

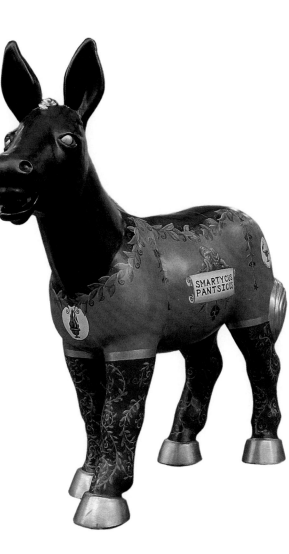

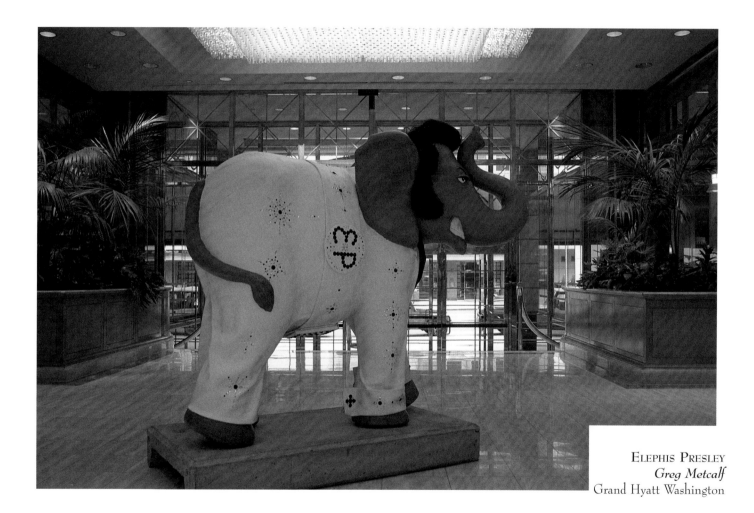

ELEPHIS PRESLEY
Greg Metcalf
Grand Hyatt Washington

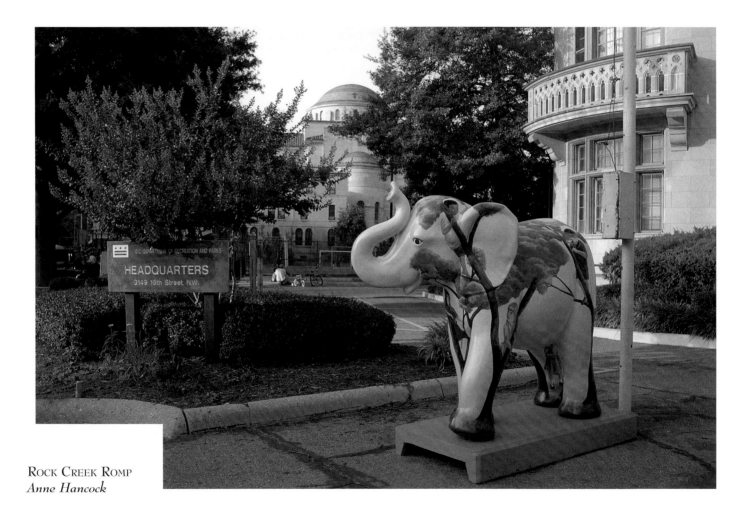

ROCK CREEK ROMP
Anne Hancock

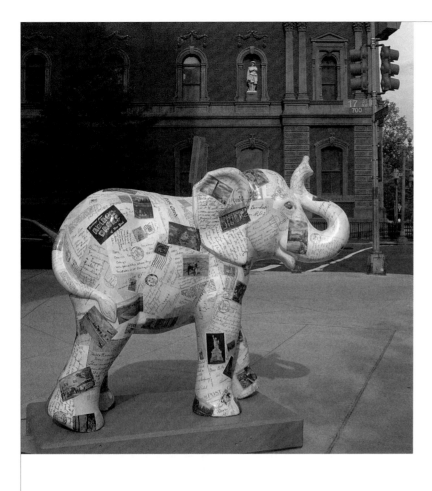

YELLOW DOG
Joyce Wellman

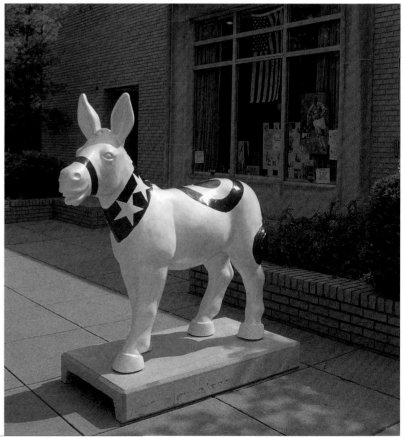

108

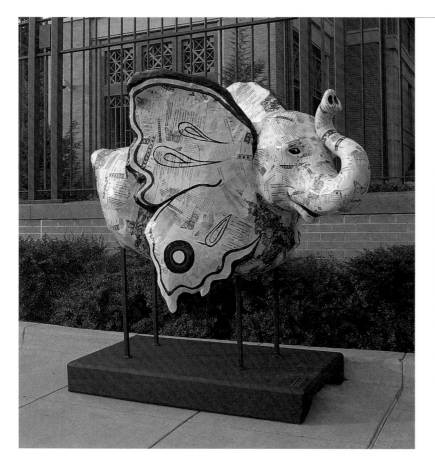

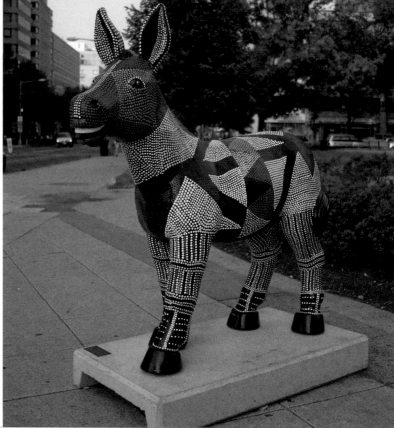

IMBONGI
Elsabe Dixon
Clark Construction

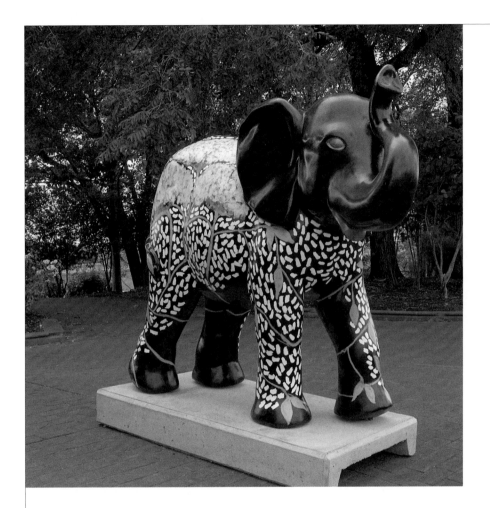

Left to right:

PARTY ANIMAL: PACKY-SANDRA
Edith Kuhnle
Nancy M. Folger and Sydney Werkman

PATRIOTIC DONKEY
Ellen Rhodes Moore
Robert M. Fisher Memorial Foundation, Inc.

LILYPHANT
Cindi Berry
Comcast

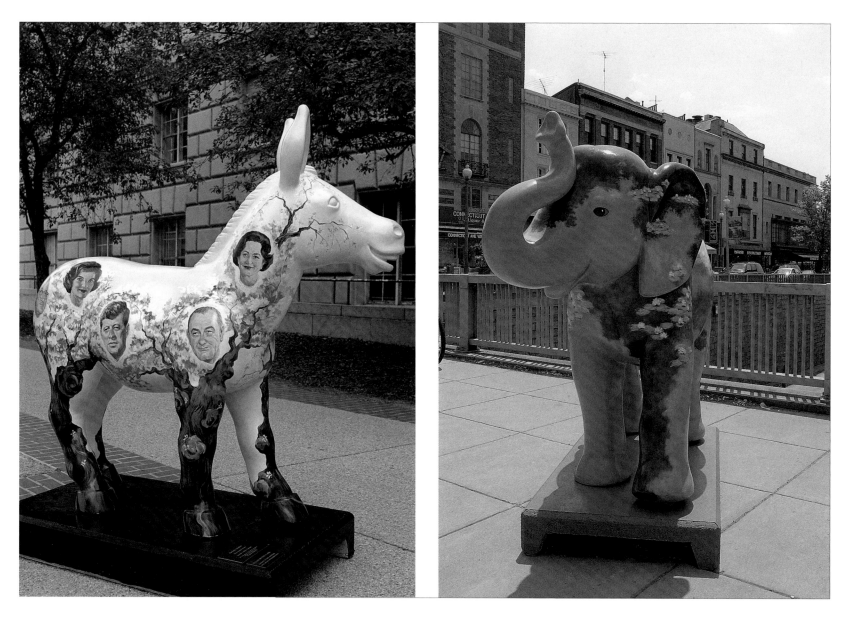

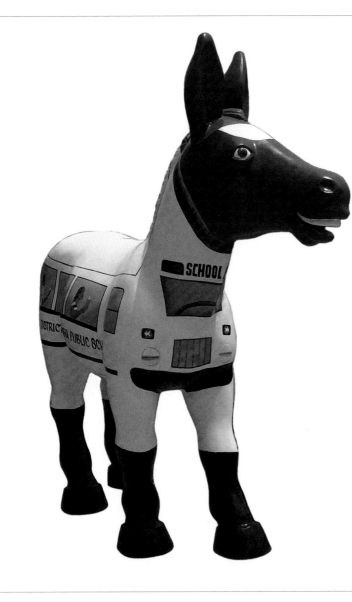

Left to right:

JUST BEFORE CLASS
Robert Alston
IN 2 Books

STRIPES-THE CAROUSEL ELEPHANT
Naomi & Byron Bloch,
Andrea, Brandon & Candice
Renaissance Washington DC Hotel

STARS-THE CAROUSEL DONKEY
Naomi & Byron Bloch,
Andrea, Brandon & Candice
US Airways

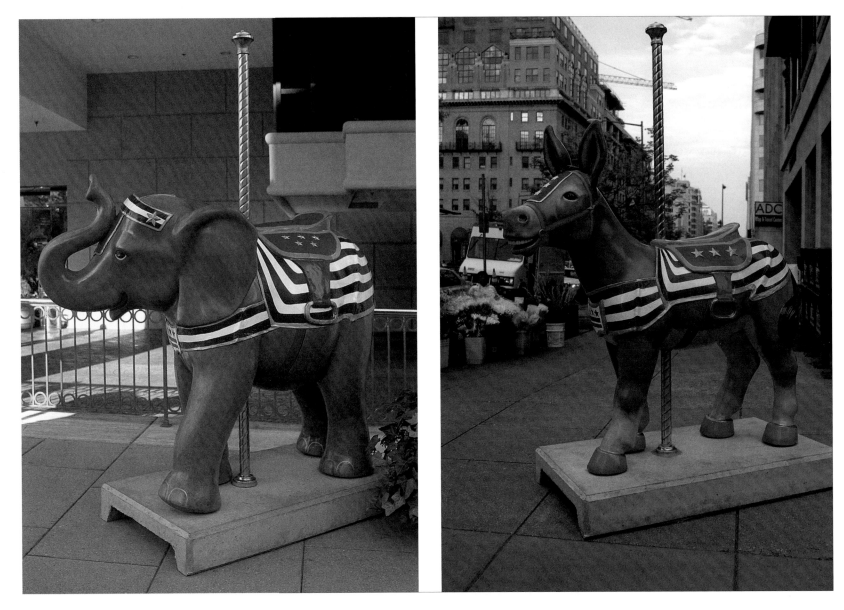

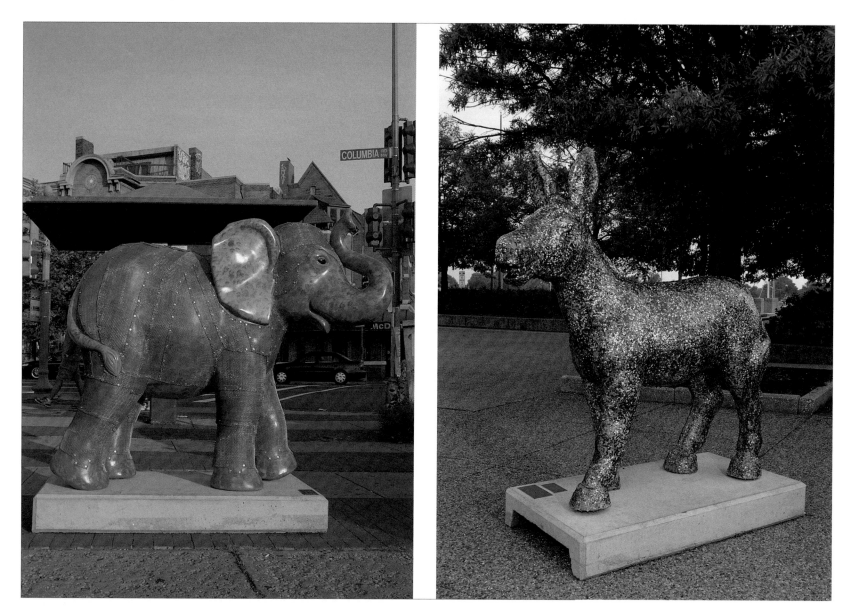

Left to right:

ARMORED BUT NOT DANGEROUS
Besty Damas

CHAD
William Niebauer & Mike Schmelyun

ELEPHANT IN CAMOUFLAGE
L.S. King

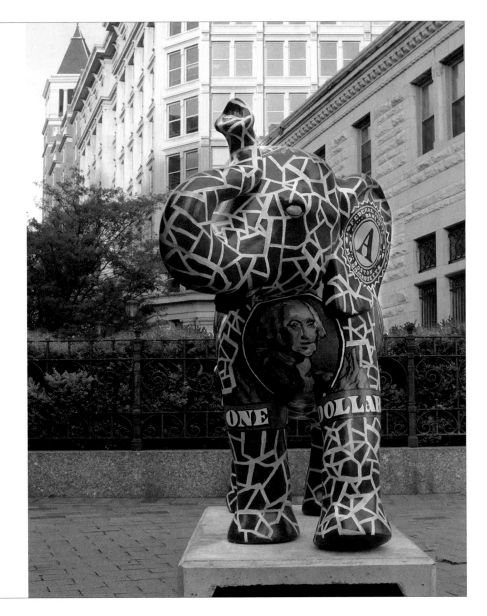

Left to right:

MARRIAGE OF CONVENIENCE
Clare Wilson assisted by Robert Alston
Hecht's

MARRIAGE OF CONVENIENCE
Clare Wilson assisted by Robert Alston
Hecht's

PARTY CHEFS
Susan Callahan
Irish Channel

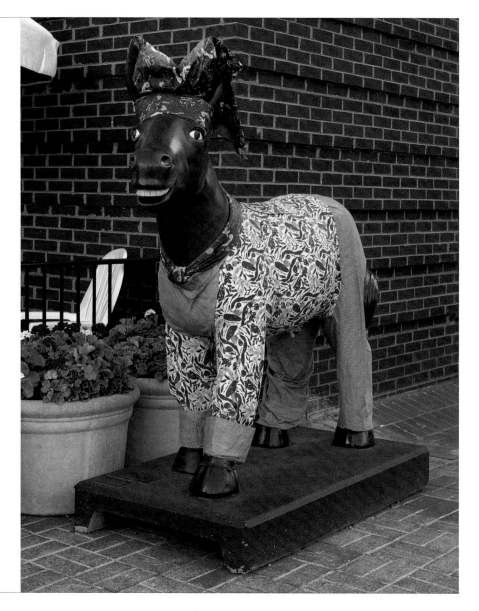

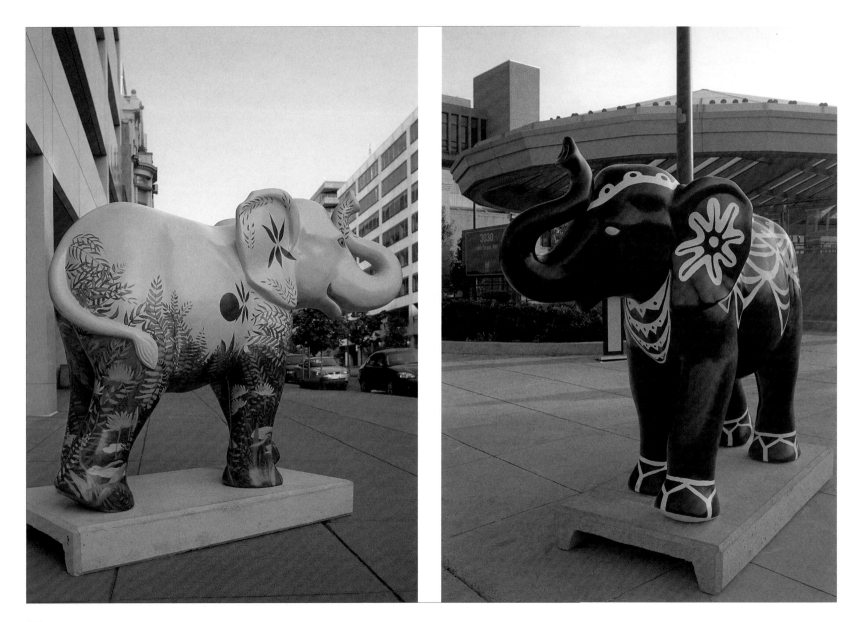

Left to right:

ROUSEAU AT LARGE
Judith Simons & Michael Grantt

SATIN DOLL
Honoria Elwell

ODE TO GRECIAN URN
Anthony Cervino
Heidi & Max Berry

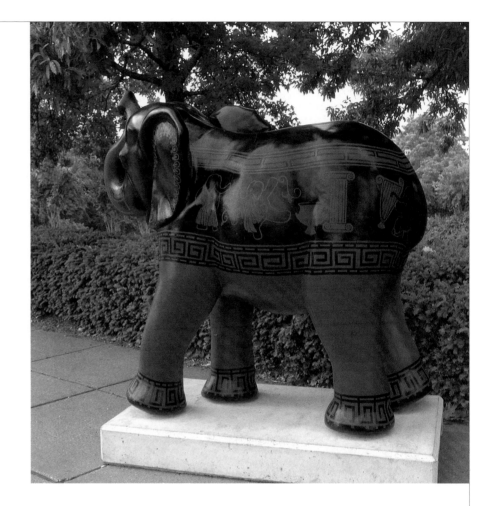

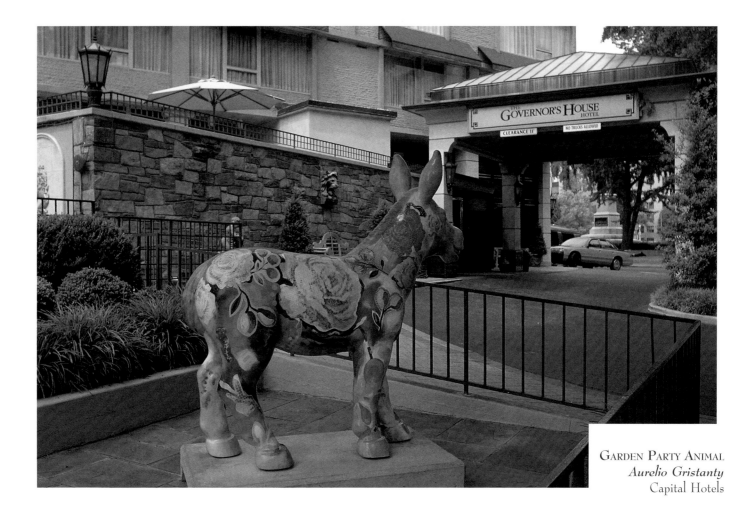

GARDEN PARTY ANIMAL
Aurelio Gristanty
Capital Hotels

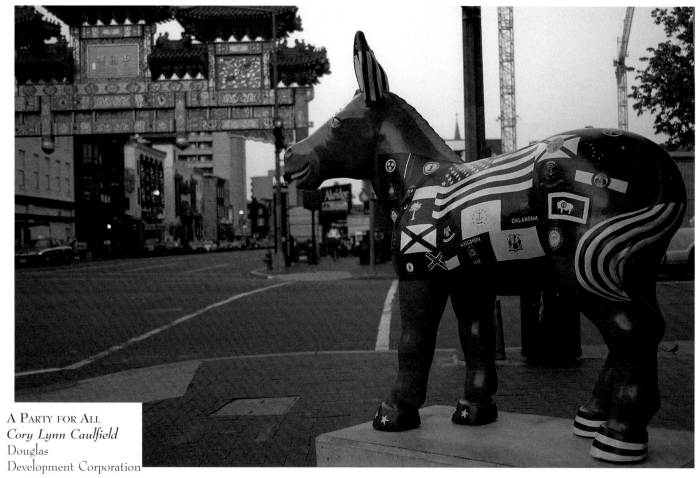

A PARTY FOR ALL
Cory Lynn Caulfield
Douglas
Development Corporation

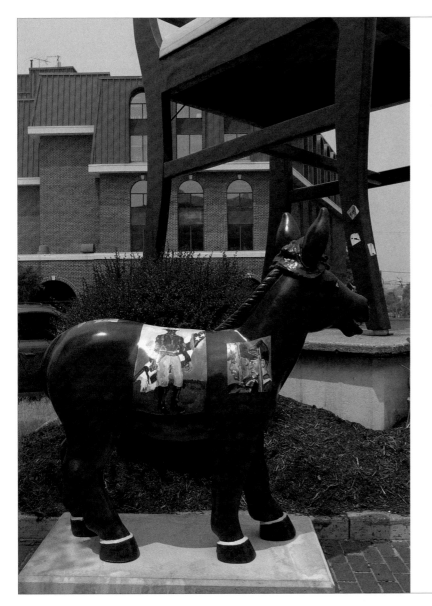

Left to right:

BUFFALO SOLDIER
Brian Martin

GRASS ROOTS
Betsy Stewart
Horning Brothers

IT DOESN'T FEEL LIKE A DONKEY
Trina O'Hara

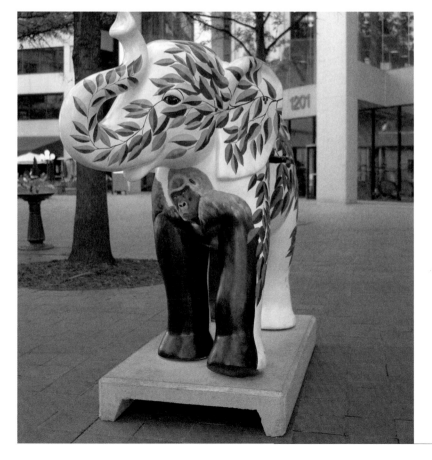

MONKEY BUSINESS
Caroline Afande

Left to right:

PEACE ROSE
Glennis McClellan
Market Development Group, Inc.

THE BEAUTY OF WASHINGTON
Linda Nay
Hecht's

40 ACRES AND A MULE
Kevin Richardson
Heidi & Max Berry

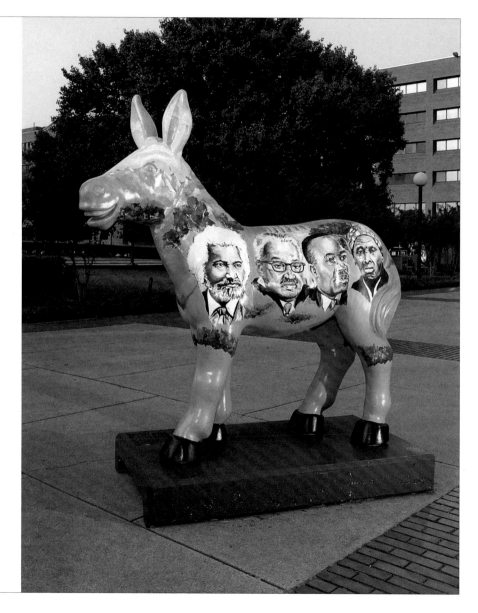

Left to right:

FUNDRAZING
Matthew Johnston
Ridgewell's

CIRCUS ACT
Mary Kiraly

DON'T BE A PARTY PAPER
Ann Currie

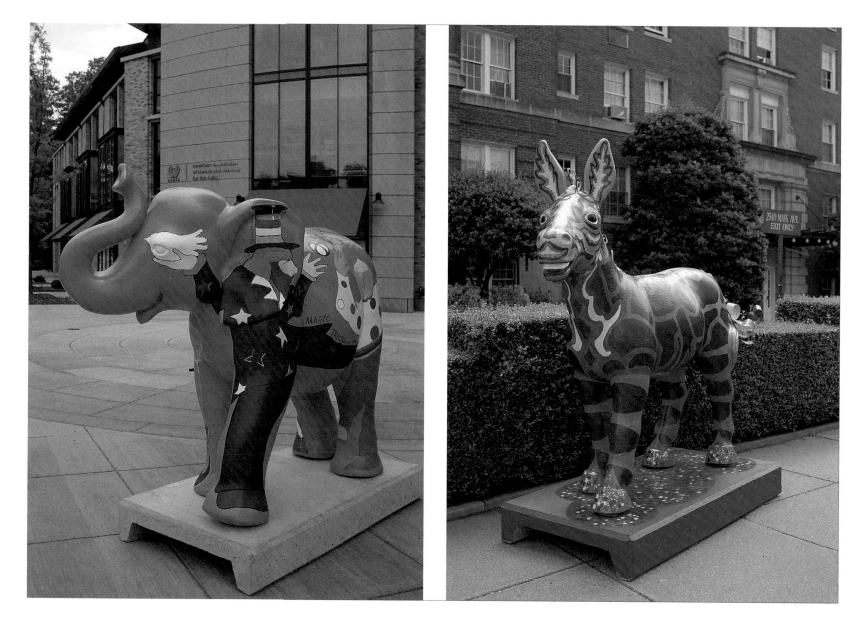

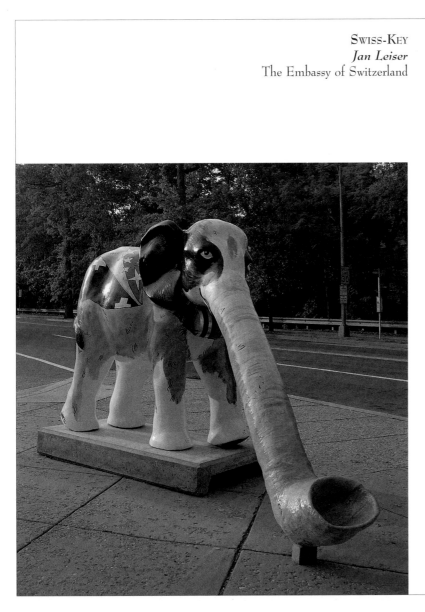

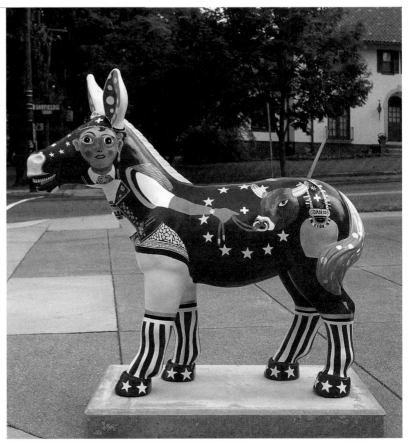

RESCUEPHANT
Annina Luck
The Embassy of Switzerland

THE CARNIVAL ELEPHANT
Marise Riddell
Washington Metropolitan Area Transit Authority

YANKEE DOODLE DONKEY
William Gordon
Crabtree + Company

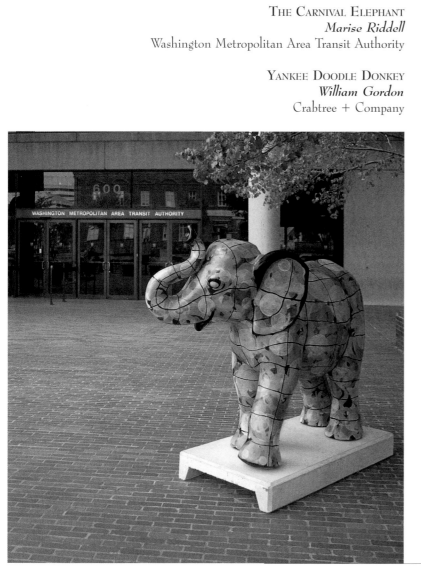

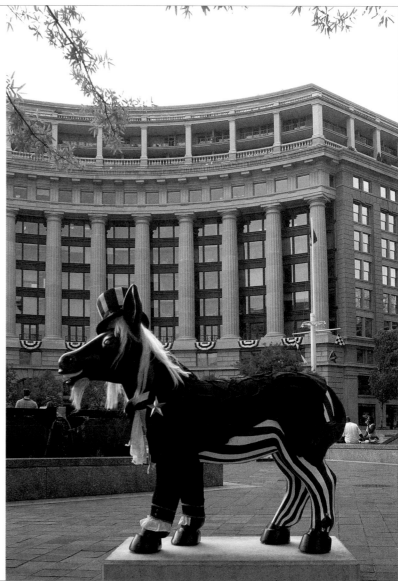

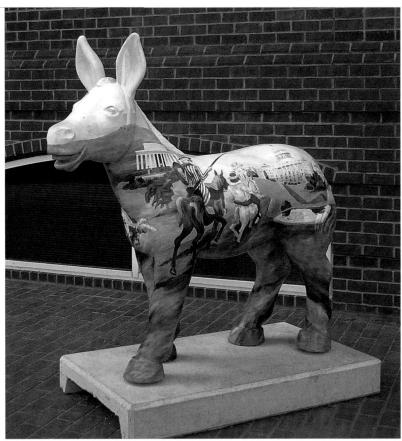

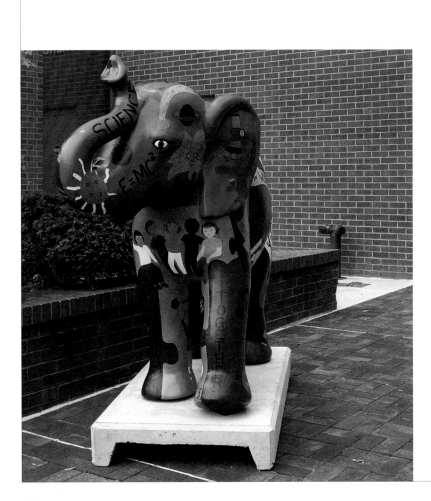

Left to right:

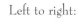

PUZZLE IT OUT
P.G. Home Learning
Network & Friends
IN 2 Books

DONKEYXOTE
John Bledsoe & Thomas Spande
Heidi & Max Berry

CITY SCAPE
Alden Phelps
Clark Construction

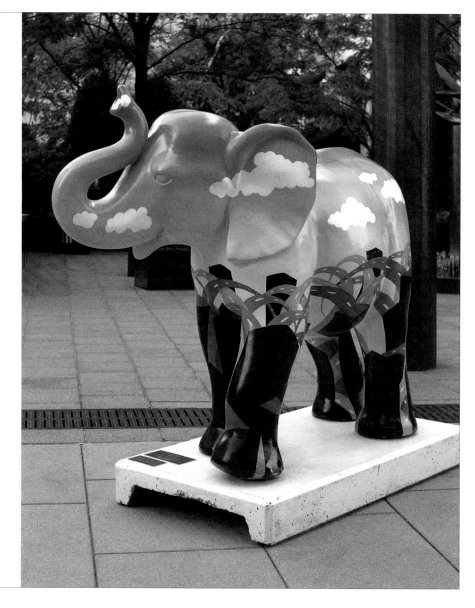

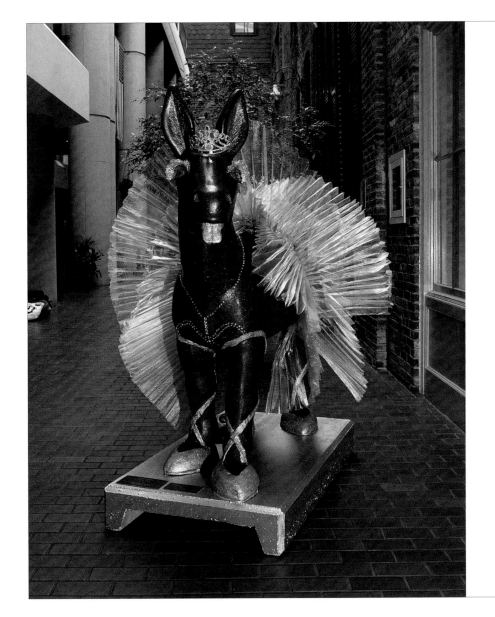

Left to right:

PRIMA DONKEY
Cheryl Foster

THE DEVINE MISS DONKEY
Jill Krasner

AZULITO
Dorothy Fix

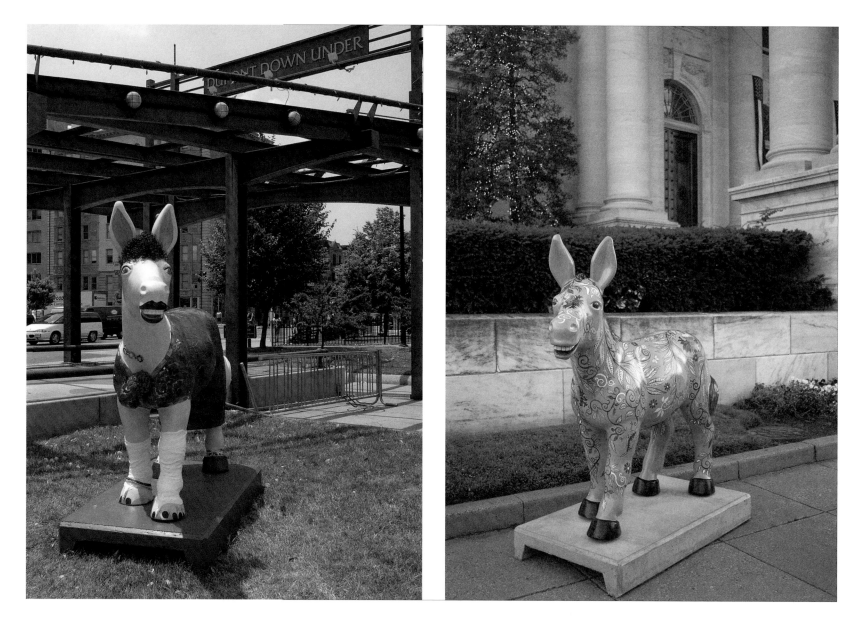

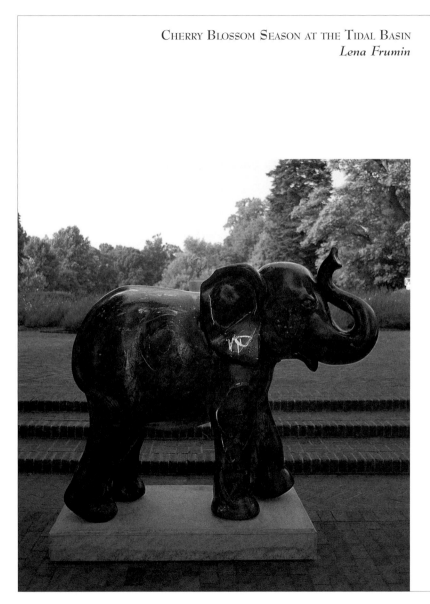

CHERRY BLOSSOM SEASON AT THE TIDAL BASIN
Lena Frumin

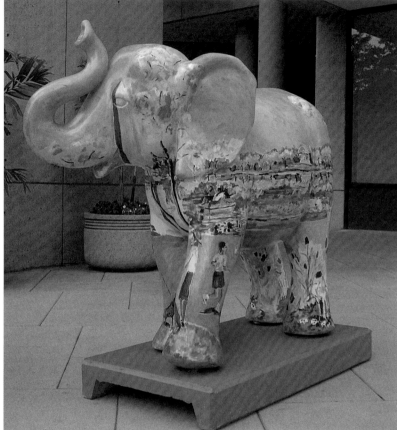

BLUE
Mindy Weisel

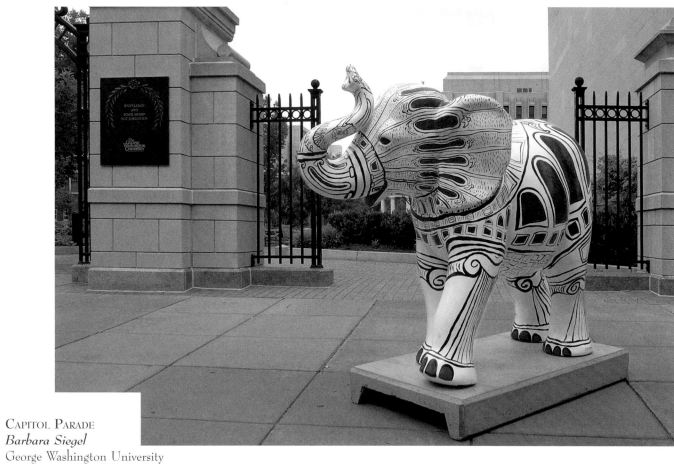

CAPITOL PARADE
Barbara Siegel
George Washington University

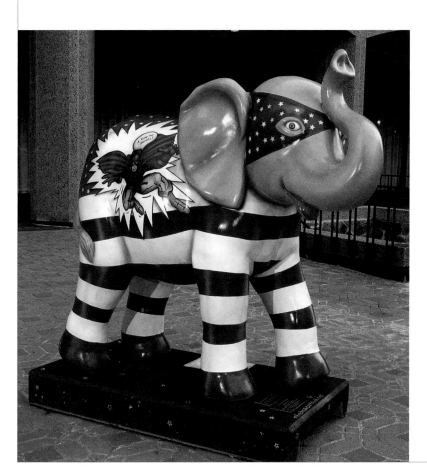

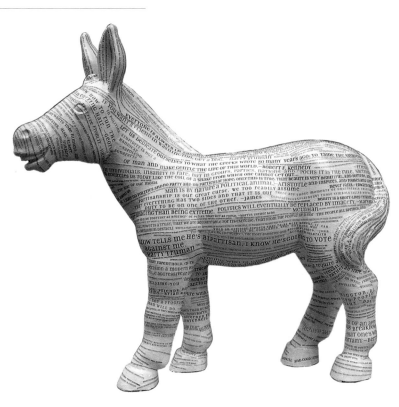

Left to right:

A TIME FOR HEROES
Margaret Finch
Lerner Enterprises-The Bernstein Companies-
Consortium Capital, LLC

BLACK & WHITE & READ ALL OVER
Justine Walden

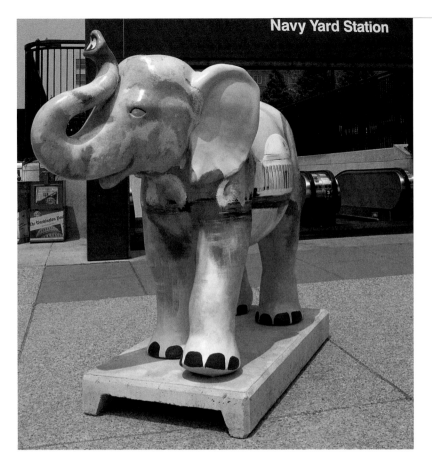

HIDING AN ELEPHANT
George Lucas
Department of Public Works

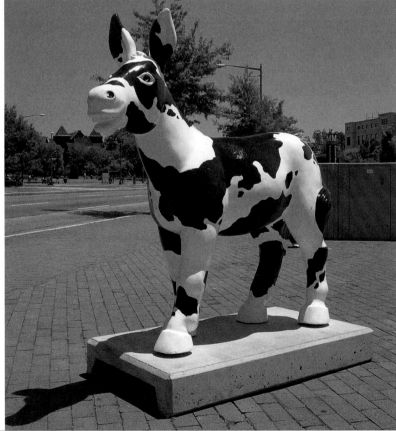

HOLSTEIN DONKEY
Bill Shimek
Giant Food

137

Left to right:

THE SPIRIT OF WASHINGTON, DC
Bonnie Printz
Holiday Inn on The Hill

MEDIA CIRCUS
Jared Davis
The Washington Times

Left to right:

ISLAND FANTASY
Thomas Farrell

THE WOMEN IN WASHINGTON ARE
BEAUTIFUL-SOPHISTICATED, TOO!
Catherine Hillis
Holiday Inn Capitol

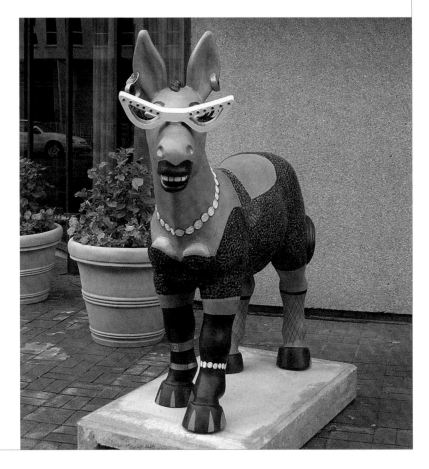

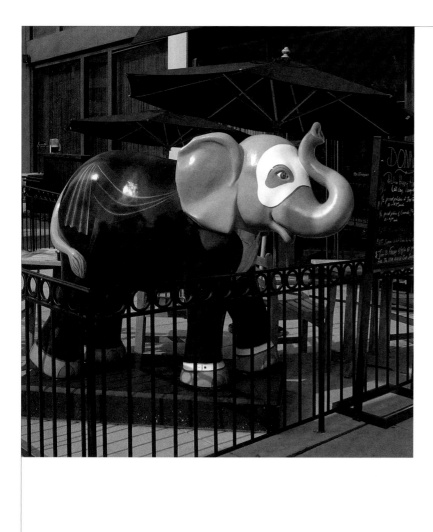

Left to right:

ELEPHANTOM OF THE OPERA
Francisco Quintanilla & Melissa Larkin
Capital Hotels

CARNIVAL ELEPHANT
Wilveria Clark

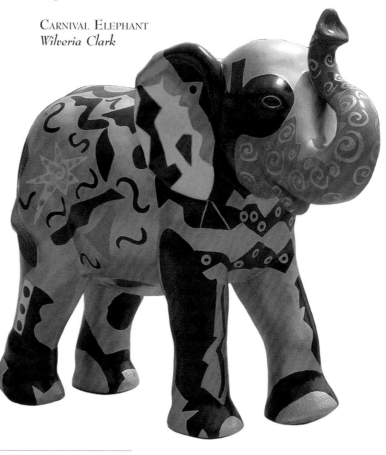

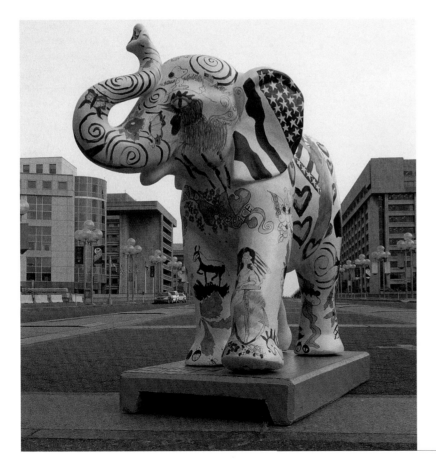

DANCING DEMOCRATS
Toni Jannelli
The Washington Times

THE TATTOOED ELEPHANT
Diana Gamerman

141

MIDSUMMER NIGHT'S DREAM
Lynn Fuerth
Dorothy & Bill McSweeny

HOOAH
Pamela Wilde

ROADSIDE AMERICA
Chris Goodwin

STUPENDOUS STRIPE
Shannon McIntyre-Bugos
Alma & Joseph Gildenhorn

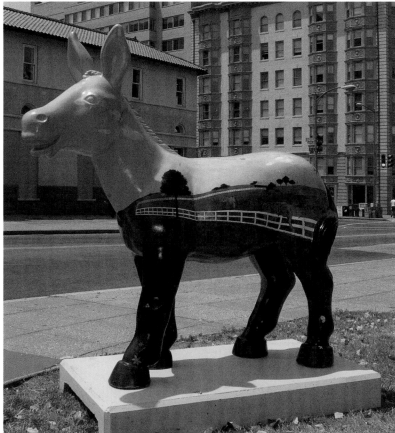

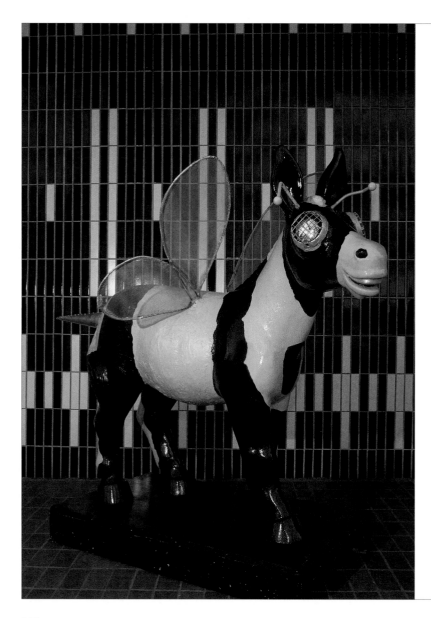

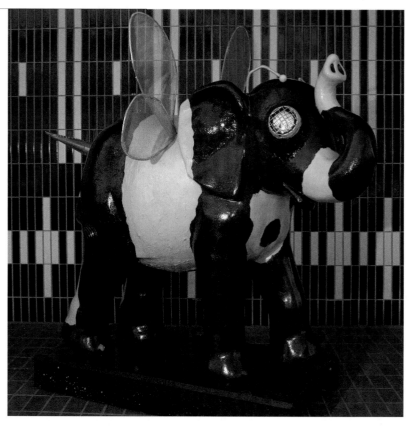

Left to right:

FLIGHT OF THE BUMBLEBEE
Joan Cox & Leslie Heins
Neiman Marcus

FLIGHT OF THE BUMBLEBEE
Joan Cox & Leslie Heins
Neiman Marcus

Left to right:

DONKEYXOTE
Francisco Quintanilla & Melissa Larkin
Shops at Georgetown Park

PARTYING IN THE HOUSE AND SENATE
Lake Anne Elementary School

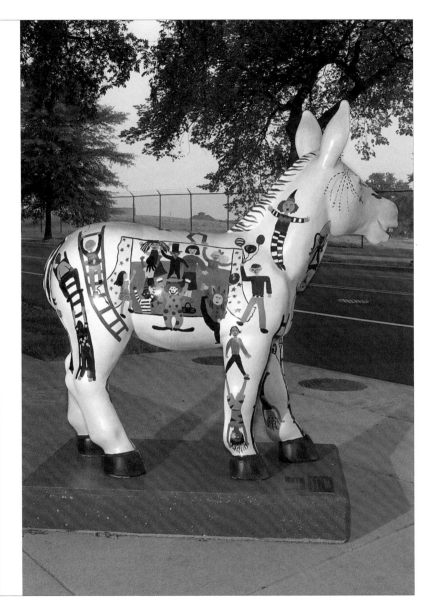

145

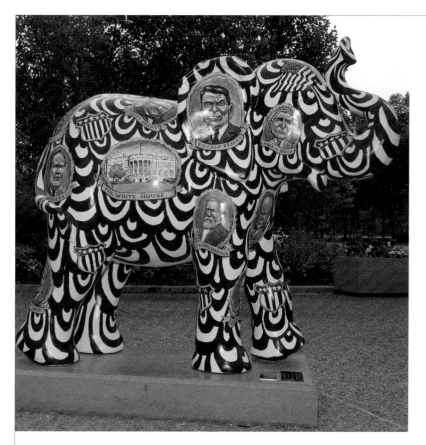

POTUS DEMOCRATUS
Matt Wuerker
National Museum of American History

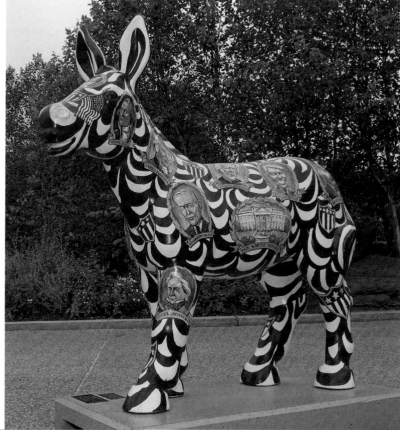

POTUS REPUBLICANTUS
Matt Wuerker
National Museum of American History

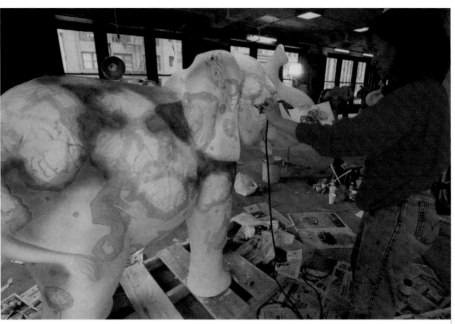

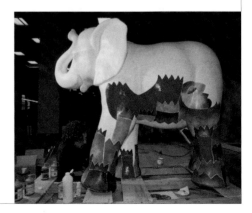

Party Animals' Sponsors

PRESIDENT

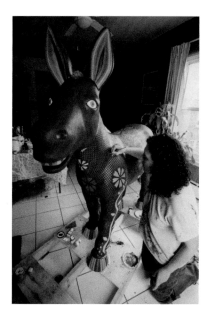

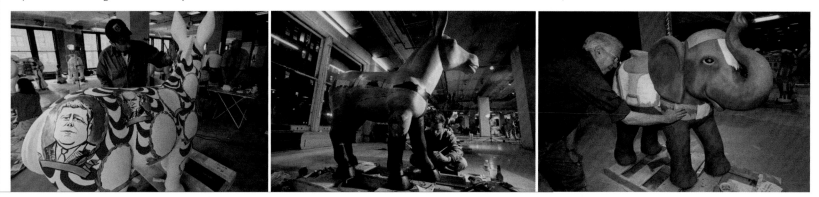

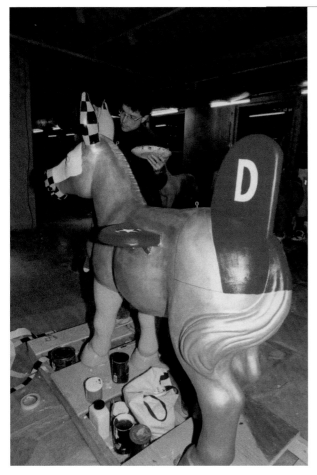

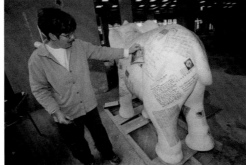

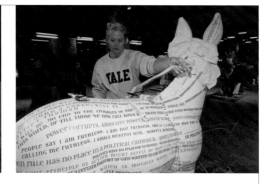

SENATOR

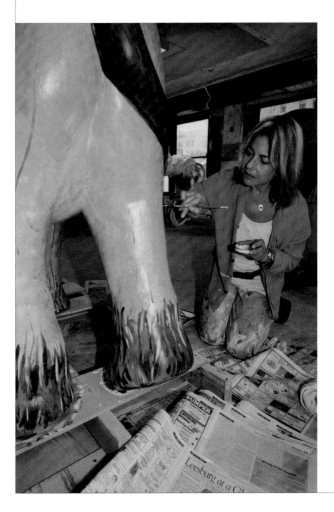

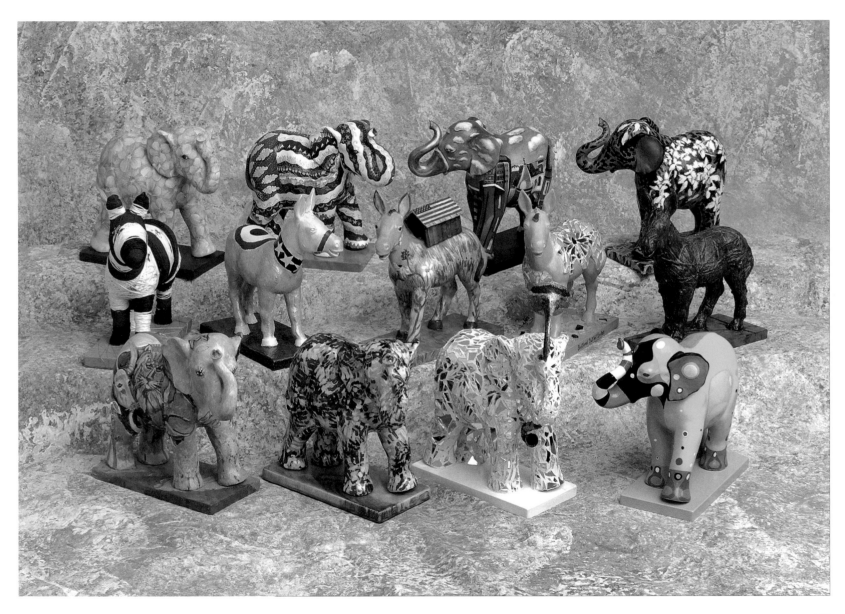

Acknowledgements

Party Animal Studio Keepers

Douglas Development Corporation
(Woodies Building)
Douglas Jemal
George Cois
Sabra Gould
Bruno Mistichelli

Preeminent Protective Services
Mr. Pat Bell
Mr. Ramon A. Cala
Mr. Avelino Jose Cala

District of Columbia Emergency Management Agency
Peter LaPorte
Steve Benefield

Friends, Volunteers and Individuals
David Bronson
Mattie Buskirk
Jose Dominguez
Sharon Roy Finch
Christopher Goodwin
Home Depot
Glennis McClellan
Fred Paine
Carolyn Parker
Nwenna Randall
Sherry Schwecten
Laura Seldman
Alec Simpson
Tom Westbrook

Party Animal Support

Clark Construction Group, Inc.
Pete Forster
John O'Keefe
Myke Price
James Tinsley
John Walker
Howard Custer
Thomas Sweetney
Enrique Vazquez
Jeff Owens
Jose Fernandez
Wilfredo Gomez
Tom Barbieri
Ken Smith

Patton Boggs LLP
Deborah M. Lodge
Paul Jorgensen

Corporation Council or the District of Columbia
Martha Mullen

U-Store
Kevin Green
Owen Dyer
William Moody

Party Animal Movers and Shakers

District of Columbia Department of Public Works
Robert Stanback
Cybil Hammond
Jamal King
Mr. T Truck Driver
Nicky West
Jonathan Pringle
Thomas Norris

District of Columbia Department of Transportation
Frank Pacifico
Horace Richardson
Johnny Holmes
Jeffrey W. Williams
Barbara J. Willis
Kenneth Smith
Myron Gross
Roland D. Jones
Russell Irving
Anthony Bell
Roland Thompson
Brian Smoot

Friends, Volunteers and Individuals
Jody Bergstresser
Bridget Bly
Tom Costello
Rufus Crokett
Jose Flores
Nick Franchot
Isabel Guisantes
Aki Hakuta
Sandy Hazen
Esther Hernandez
Carlos Hernandez
Steve Koczaro
Ro Ma
Alex Mayer
Jared Press
Kelly Putman
Eric W. Russell
Will Stovall
Maurizio Yanes
Yeman

Party Animal Barkers / Enthusiasts

Robert Alston
Lori Banschbach
Sandra Barton
Carolyn Barry
Lazaro Batista
Howell Begle
Burkey Belser
Byron Bloch
Naomi Bloch
Jonathan Bruns
Donald A. Brown
Jill Cornish
Jo Deutsch
Tory Flowers
Hillery Garrison
Gail Gorlitz
Reggie Govan
Donna Greenfield
Marcy Hawley
Vada Hill
Deena Hyatt
Ben Jacobs
Danny Kalicka
Janice L. Kaplan
Carol Kelly
Kwik Kopy
Leslie Landsman
Leonard Lee
Judy Licht
David Levy

Michael McBride
Lee Kimche McGrath
David Mog
Ylan Q. Mui
Johanna Neuman
Robert Peck
Potomac Gazette
Rusty Powell
Jackie Randolph
Janet Rathner
Al Rickard
Jacob Sarasohn
Susan Sarfati
Joan Shorey
Di Stovall
Martin Smith
Kris Swanson
Tasty Shirt Company
Rufus Toomey
Jacqueline Trescott
Teresa Williams
Darrell Willson
Jen Waters
Washington Post
WETA
Vinnie Wohlfarth
John Woo
Sandrea Wollfolk
Crabtree + Company

Lucinda Crabtree
Sylvia Courembis
Greg Bramham
Forrest Dunnavant
Catie Finn
Tamera Finn
William Gordon
Robin Ludt
Nicholas McMillan
Susan Mertz
Shaveta Moore
Nisha Nair
Tracie Parker
Chris Raymond
Lisa Suchy
Russell Surles

J. Steward Johnson was assisted in the painting by:

Michelle Post (Mama Duck)
and the Quacked-up Septet:
Helen Uger
Joni Fitzgerald-Alyea
Margaret Maurice
Elizabeth Hutchinson
Christina Mancuso
Deborah Caiola
Lindsey Young-Lockett

Inspired and Interesting Ideas

Chad Alan
STROM P. 97
"The elephant was worked on by 16 people. It has 50 feet of copper tubing, 3 bike rims, 47 cans of spray insulation foam, and over 14 miles of bailing twine."

Jude Andreasen
MONARCH BUTTERFLY ELEPHANT P. 54
"Artistic license was taken in her wing design, but the colors and shapes are close approximations of the Monarch butterfly's wings."

Joseph Barbaccia
PARTY LINES P. 84 R
"I used 4 miles of marine line on the donkey."

Mary Beth Bellah
PATCHWORK OF PEOPLE P. 88 L
"Patchwork of People actually fits the definition of a quilt (3 layers held together with stitching). The backing (layer) is the animal form followed by a bathing layer with the fabric layer sewn on piece by piece (and decorative stitching added at points of interest)."

Jody Bergstresser
BROWN STONE MARBLE AND TREES P. 74
"I take my dog Atlas on daily walks by brownstone homes and marble fountains in our lovely city of trees. When no squirrels are in sight, Atlas waits patiently if I stop to sketch."

Byron Bloch
"STAR" THE CAROUSEL ELEPHANT AND "STRIPES" THE CAROUSEL DONKEY P. 113
"We did this as a family project...involving our three young-adult children...Andrea (26), Brandon (21), and Candice (19). This was a true 'family project' that was a labor of love for us all...working closely together day after day (and often into the night). We used authentic brass carousel poles, of the traditional 'spiral rope' design, and we

personally sculpted the saddles, blankets, and trappings to honor the traditional design elements of historic carousels over the past century."

Irene Clark
HELIANTHUS ELEPHANTHUS P. 51 L
"The elephant is painted entirely with sunflowers and each flower is unique."

Ann Currie
DON'T BE A PARTY PAPER P. 127 R
"My donkey is covered with hundreds of little squares of handmade paper 'confetti.' The paper is made of flax, chosen because the fibers are strong and waterproof. Individual sheets of hand-dyed flax were formed and dried. Then the sheets were cut into little squares."

Melissa Daman
AFRICAN ELEPHANT P. 38
"I have hidden pictures of myself and my two sisters (as children) in the painting. I did that because my oldest sister was dying of cancer as I worked on the piece. I told her I was going to do that and that the three of us would be forever together on that elephant. She has since died so it means a great deal to me."

Joan Danziger
SPIRIT BIRD RISING HIGH P. 43
"The donkey had 80 feet of chicken wire in its construction besides much sweat and torn gloves."

Jared Davis
MEDIA CIRCUS P. 138 R
"The elephant has 8 kinds of media on it: print media, web media, television media, radio media, painting media, photographic media, sculpture media, and collage media."

Dorothy Donahey
AWARENESS DONKEY P. 66
"My Party Animal has a yellow ribbon for lost and missing persons, a red ribbon for AIDS

awareness, a pink ribbon for Breast Cancer, a green ribbon for Earth awareness, and the most important is a red, white, and blue ribbon to represent September 11th and all America. Mayor Williams told me he likes my donkey because he is wearing a red, white, and blue bow tie! My artwork always features ribbons."

Gary Fisher
POTOMAC FEVER P. 85
"The elephant, aka Maxine, has a hidden inscription on it, dedicating it to my mother, Maxine, who had her 90th birthday the day I finished painting. My mother was an artist, now in Wyoming, who is confined to a nursing home suffering from Alzheimers."

Lynn Fuerth
MIDSUMMER NIGHT'S DREAM P. 142 R
"Find Patrick Stewart's signature along with his favorite quote from "A Midsummer Night's Dream" on the donkey."

Sofia Gawer-Fische
BORRICO RICO P. 61
"I painted in my donkey 21 flowers and COUNTLESS dots, and it has the most colorful teeth! The design is inspired by the Oaxaca style, folk art from Mexico."

Carla Golembe
ELEPHANT OF INFINITE DREAMS P. 42 R
"It has 7 or 8 layers of paint, each one transparent, which is what gives it the luminous surface."

Chris Goodwin
ROADSIDE AMERICA P. 143 R
"Some of the trash painted onto Christopher Goodwin's donkey, 'Roadside America,' is based on actual trash Mr.Goodwin found in his front yard!"

Normon Greene
DREAM 2 GOD BLESS THE WORLD P. 28 (L)
"There are 22 countries represented on the

donkey: France, Norway, Panama, Liberia, the Philippines, Kenya, Singapore, Tibet, Trinidad/ Tobago, Jordan, Israel, Japan, the US, South Korea, Barbados, Australia, Scotland, Vietnam, Uganda, Brazil, American Samoa, and India. Also, Washington, DC!"

Gary Jameson
GRAND OLD PACHYDERM P. 22 L
"The 'Grand Old Pachyderm' has 51 stars in the blue field advocating statehood for DC."

Katherine Kahn
A GARDEN OF EARTHLY DELIGHTS: PERSIAN FANTASY P. 78
"The artist's name is hidden in the design."

Jill Kranser
THE DIVINE MISS DONKEY P. 133 L
"She is 'what Bette Midler would look like if she were a donkey' and created by the artist in respectful homage to Bette Midler."

Lombardi Cancer Center, Tracy Councill
ELEPHANT WISDOM P. 12
"Over 50 parents, family members, and staff worked on the elephant, creating approximately 300 wish tiles. It is covered in 40 lbs. of grout, 100 lbs. of hand-cut and painted clay tiles, and about 50 glass tiles. Our sculpture outlines the skeleton of the elephant because the children wanted it to look 'x-rayed' since they have lots of such tests."

Annina Luck
RESCUEPHANT P. 128 L
"This is the longest Party Animal with a total length of 9 feet and 6 inches. The horn is 5 feet and 5 inches in length."

Rosemary Luckett
ELEFANTASY P. 26
"The basis for my elephant design is the poem by the Englishman Geoffrey Saxe based on an old Indian story about six learned blind men who tried to figure out what an elephant looked like."

from the Artists

Myra Maslowsky
THE TRIUMPH OF ALTRUISM AND PATRIOTISM P. 31 R
"My donkey is inspired by my mother. The pink rose is for her name-*Rose*. She was born on the 4th of July, hence the patriotic theme."

Glennis McClellan
PEACE ROSE P. 124 L
"2002 is the Year of the Rose."
WASHINGTON MONUPHANT P. 17 R
"A sleeping dog and boy are hidden somewhere on the statue."

Debbie Mezzeta
WHY DO ELEPHANTS PAINT THEIR TOENAILS RED—SO THEY CAN HIDE IN CHERRY TREES P. 35 L
"The elephant has a hidden smashed cherry–that the elephant just walked over–painted under its right back leg."

Mary Fran Miklitsch
JUST VISITING P. 45 R
"My donkey has 384 inches of shoe laces. Tourists think he is an FBI agent. Locals know he's a tourist."

Ellen Rhodes Moore
PATRIOTIC DONKEY P. 11 L
"Changes in the civil rights are what prompted me to choose the faces I chose for my donkey. All those faces affected our lives, I believe. Also, the cherry blossoms were represented because they are one of my favorite things about Washington. I especially love the "knarled trunks" of the old cherry trees and the way they twist and turn. The legs of the donkey were perfect for that as they were knobby and bumpy. The design of the trunks was the first thing I worked on and everything else fell into place. I purposely did not decorate the face because I wanted this to be a scene painted on a donkey as a canvas, not as though I were painting a donkey."

P.G. Home Learning Network and Friends
PUZZLE IT OUT P. 130 L
"26 kids from Maryland, DC, and Virginia worked on the elephant. All of the kids learn at home. The concept was proposed by an 11 year old, but the ages of the kids who worked on it range from 7-15 years old."

Marise Riddell
CARNIVAL ELEPHANT P. 129 L
"My elephant was designed on the computer in layers and it has 22 layers of design (paint). The order of the layers was important to the overall appearance. The computer aided me in deciding which layer would be on top of another."

Elizabeth Riordon
HOME SWEET HOME P. 87 R
"The elephant's cherry blossom branches were made from brown grocery bags and Elmer's white glue."

Chary Robbins
BLUE REFLECTIONS P. 91
"This donkey has three quarts of Rustoleum's Painters Touch Navy Blue base coat, 158 lbs of hand-shattered mirror (shattered on the ground with hammer so I took all of the bad luck out of the City) applied to the fiberglass body with 58 8 oz tubes of E6000 Epoxy, 93 tubes of cobalt blue acrylic grout (each mirror piece is individually grouted), and 120 containers of cobalt blue glitter (added separately)."

Laura Seldman
TRAVEL TRUNK P. 108 L
"The earliest postcard on the elephant dates from 1905. The postcard from the 1939 World's Fair is extremely rare."

Bill Shimek
HOLSTEIN DONKEY P. 137 R
"The donkey was inspired by my surroundings in rural northern Maryland, where the Holstein cow is the predominant farm animal."

Judith Simons and Michael Gantt
ROUSSEAU AT LARGE P. 118 L
"Nicknamed 'Henrietta,' the elephant is based on the fanciful, naïve art of French painter Henri Rousseau (1844-1910). On Henrietta's front leg is a portrait of Kandula, the baby Asian elephant born on November 25, 2001 at the National Zoo."

Dustin Smith
AMAZEING! P. 83 L
"More than 750 feet of blue masking tape was used to layout and paint the lines of the maze on the donkey 'Amazeing!'"

Di Stovall
AMERICA THE BEAUTIFUL P. 30
"Since 1968 I have wanted to illustrate the song *America the Beautiful*, because it is so descriptive of our nation's landscape. After September 11th I felt that the time was right."

Joe Sutliff
PENNY P. 25
"There are 14,307 pennies on the elephant, with 2 tails up and all of the others heads up!"

Kelly Talbott
JAZZIN' ON U STREET P. 44
"The piano keyboard that makes up this donkey's 'teeth' is actually made from a photo of the large piano keyboard that decorates the exterior of the Bohemian Caverns on U Street today."

Rufus Toomey
50 FEATHERED FRIENDS AND FLOWERS P. 60
"My elephant has the official state flowers and state birds from all 50 states."

Steve Walker
POLLOCK-TICIAN P. 36
Art teacher Steve Walker incorporates the abstract expressionistic style of Jackson Pollock in his classes at Gaithersburg High School. Instead of jazz, which is what Pollock painted to, Walker plays techno music while the students 'action paint' to the pulsing beat, resulting in huge canvasses of wild, colorful splashes.

Washington Calligrapher's Guild
ELEPHANT WALK P. 28 R
"Our elephant is decorated totally in calligraphy, with over a dozen different lettering styles based on ancient alphabets."

Mindy Weisel
BLUE P. 134 L
"I used enough paint to paint the entire exterior of a huge Georgetown home. I have 5 layers of paint!'

Wooly Mammoth Theatre Company
MAMMOTH MAGIC P. 100
"The elephant 'Mammoth Magic' is based on a set design for a recent Woolly Mammoth production of 'Spain.' In the model box containing the drawing of our elephant concept is a human figure. The figure is a self-portrait of our set designer, Robin Stapley, while a student in England."

Jody Wright
PANORAMIC PACHYDERM P. 102 L
"The elephant displays lounging lizards from the Anza Borrego Desert of California, portly penguins from the Arctic regions, a jeering jaguar from central America, gangly giraffes from Africa, elongated eagles of the US, prowling pumas of South America, and even a targeted toad (about to fall prey to the snake hanging above it!)."

Matt Wuerker
POTUS REPUBLICANTUS P. 146 (L & R)
"This elephant has cartoon portraits of every Republican who was elected by popular vote to be President of the United States."
POTUS DEMOCRATICUS
"This donkey has cartoon portraits of every Democrat who was elected by popular vote to be President of the United States."

Index of Artists

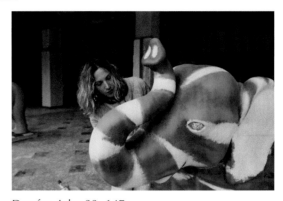

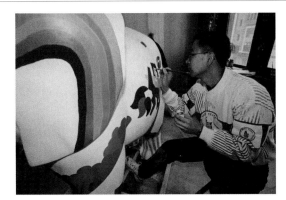

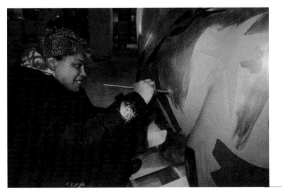

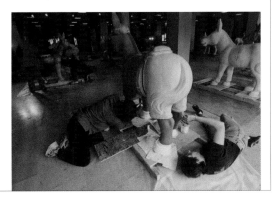

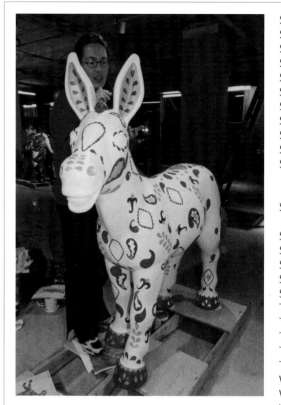

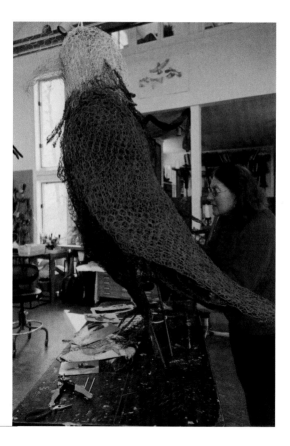

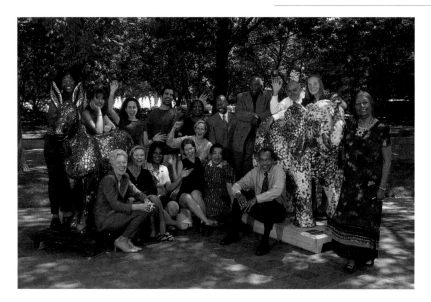

DC Commission on the Arts and Humanities Staff

Dorothy Pierce McSweeny
 Chair
Anthony Gittens
 Executive Director
Alec Simpson
 Assistant Director
Katie Dargis
 Folk & Traditional Arts
 Program Consultant
Jose Dominguez
 Special Programs & New
 Initiatives Officer
Shirin Ghareeb
 Executive Assistant
Christina Hambrick
 Art in Public Places
 Consultant
Mary Liniger Hickman
 Art Education Coordinator

Michael Jenkins
 Accountant
Dolores Kendrick
 Poet Laureate of D.C.
Samantha Lane
 Project Assistant
Alexandra MacMaster
 Art in Public Places
 Coordinator
Lionell Thomas
 Legislative and Grants
 Officer
Cecilia Weeks
 Support Services Supervisor
 & Office Manager
Carolyn Parker
 Information Specialist
Nwenna Randall
 Program Assistant